G000164885

ILFRACOMBE

THROUGH TIME

Peter Christie &
Graham Hobbs

AMBERLEY PUBLISHING

First published 2012

Amberley Publishing
The Hill, Stroud, Gloucestershire, GL5 4EP
www.amberley-books.com

Copyright © Peter Christie & Graham Hobbs, 2012

The right of Peter Christie & Graham Hobbs to be identified
as the Author of this work has been asserted in accordance
with the Copyrights, Designs and Patents Act 1988.

ISBN 978 1 4456 1189 1 (print)
ISBN 978 1 4456 1197 6 (ebook)

British Library Cataloguing in Publication Data.
A catalogue record for this book is available from the
British Library.

Typesetting by Amberley Publishing.
Printed in Great Britain.

Introduction

This book has its beginnings in Bideford. Early in 2012 the publishers approached us to produce a publication to be called *Bideford Through Time*, where old photographs would be combined with ones showing the same sites today. This we did, which was well received, and then Amberley asked us to produce a similar one for Ilfracombe. One might ask why would readers want to own such a volume? There have been, after all, a fair number of excellent books on Ilfracombe already, and we suspect there will be many more; but we believe it is only by seeing the old and new photographs side by side that one realises just how much change has occurred. Some of the changes, such as the disappearance of the extravagantly grand Ilfracombe Hotel and the Pavilion, are obvious, but look at the backgrounds in our choice of old shots and notice how posters, fashions and even street furniture have all changed. It is this accumulation of both small and large details that makes up the changes that we are surrounded by, and which we are often not even aware of. When producing the new shots we have attempted to include as many people as possible, if only because this volume will act as a record of much of Ilfracombe in the year 2012, and so, we hope, will be useful to historians in the future. We have deliberately included shots from the last sixty years rather than just use Victorian and Edwardian photographs in order to give present-day residents a closer link to the pictures. By doing this we hope to bring out the sense of community that is palpable in Ilfracombe, and we would like to dedicate this volume to the people of Ilfracombe – especially those who consented to be in the pictures.

Peter Christie has published twenty books and over 1,000 newspaper articles on the history of North Devon. Graham Hobbs is a photographer of thirty years who has won many awards, including worldwide recognition for his commercial work.

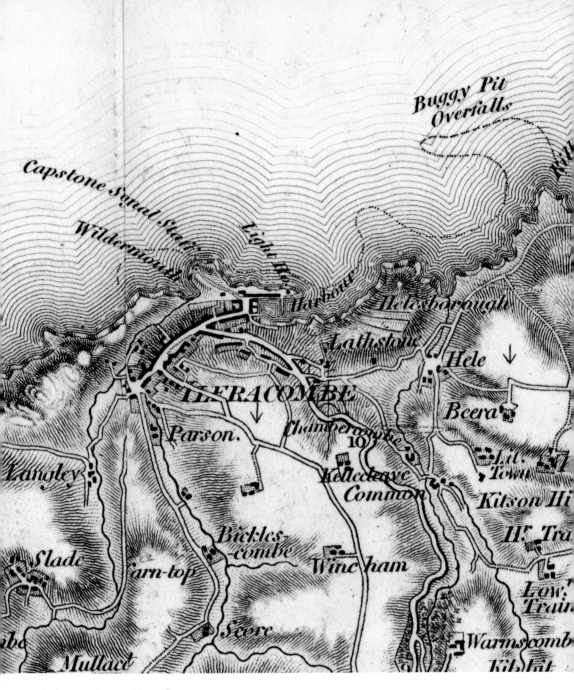

Ordnance Survey Map 1809
The very first Ordnance Survey map to show Ilfracombe was published on 11 October 1809 by Lt-Col. Mudge. Produced before contours were used, it shows the hills around the town by hill-shading or hachuring. At this date Ilfracombe was relatively small and both Slade and 'Bicklescombe' are distinct hamlets.

4

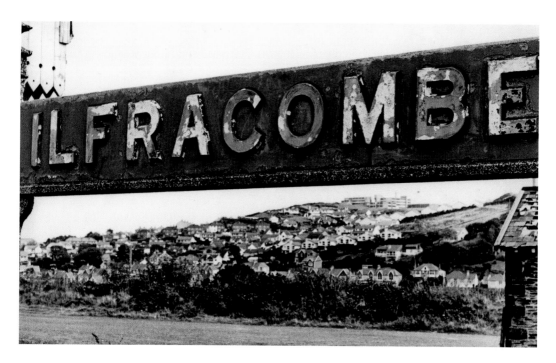

Land Transport in Ilfracombe

These two signs sum up the history of land transport in Ilfracombe. The old railway sign records the coming of the train to the town in 1874, whilst the modern road sign shows the variety of attractions on offer along with the names of Ilfracombe's two twin towns of Herxheim (Germany) and Ifs (France).

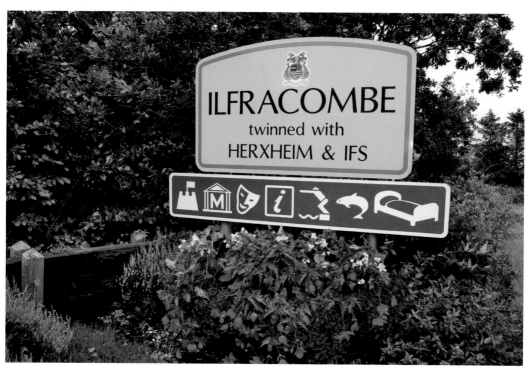

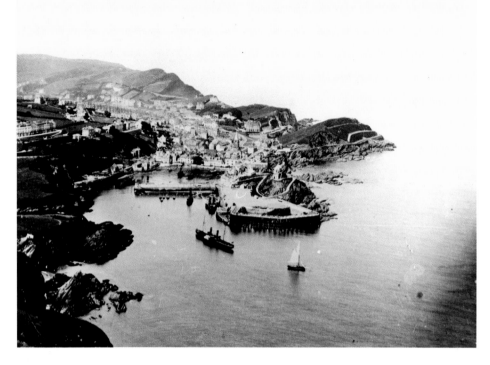

A Favourite Postcard

So common is this view of Ilfracombe that it must have been one of the favourite postcards before the First World War, and it is a very handsome picture. Our updated version shows the new pier area well and the new developments on the left of the shot. The beautiful setting of the town is obvious in both.

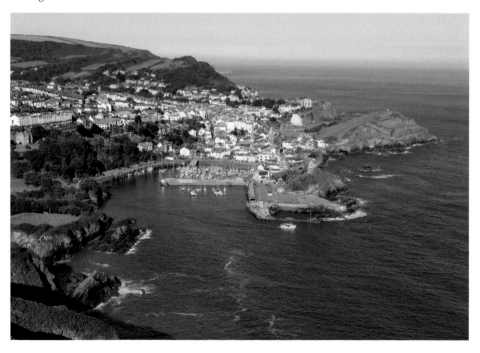

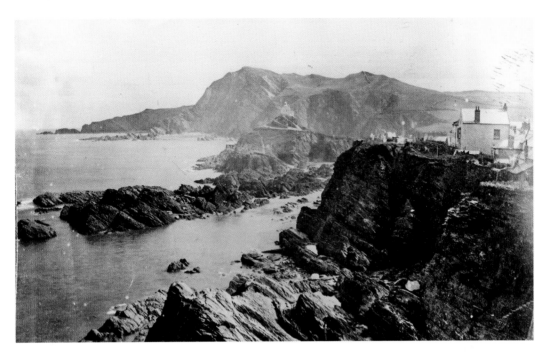

The Coast I

The timeless nature of the coast is caught well here with the original photograph from around 1890 looking very much the same as the 2012 shot, though the small buildings on the right have been replaced with larger guest houses catering for the Edwardian tourist boom. The rocky harbour was the key to the town's early growth both in trade and fishing.

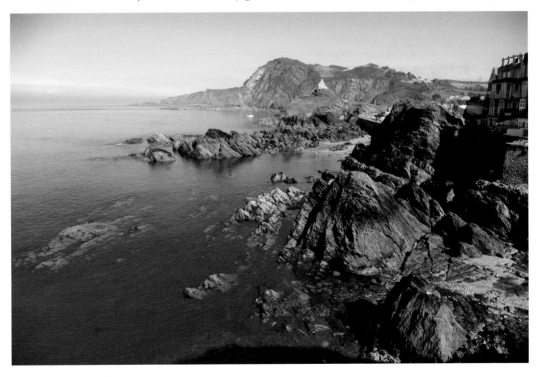

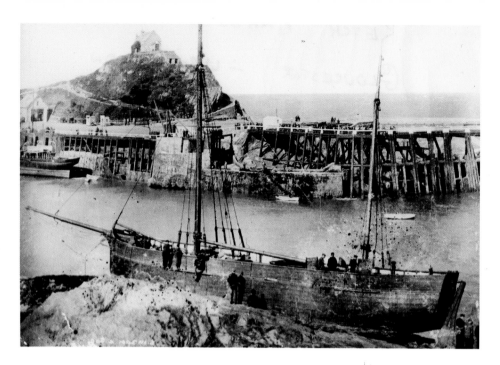

The Old Pier and St Nicholas' Chapel

The old pier and St Nicholas' chapel (dating from the fifteenth century at least) are shown well in this shot from 1895. The same view today shows the hill on which the chapel sits to be much greener, and the pier greatly reinforced, with motor vessels in place of the sailing craft. The wooden ketch in the earlier shot is the *Arabella* of Gloucester, which was wrecked on the Britton Rock in October 1895 with the loss of its four-man crew along with two local men.

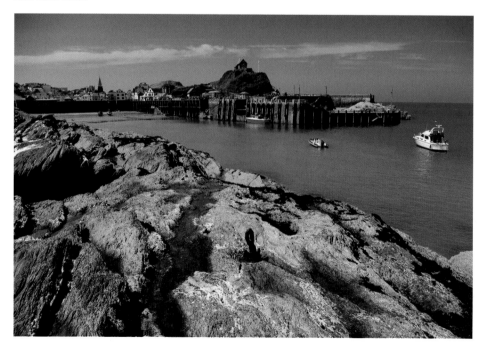

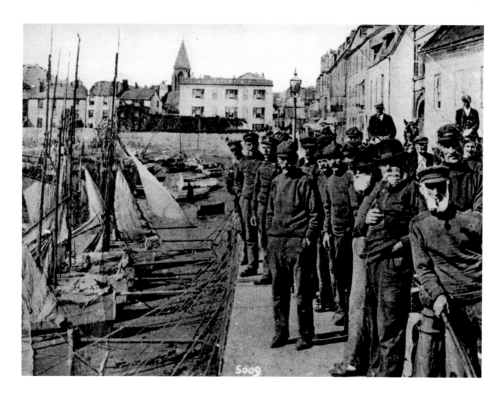

The Harbour I

Ilfracombe grew around its harbour and, as such, it always seems to be crowded. The photograph above dates from around 1890 and shows a crowd of sailors and fishermen with a pair of horse-drawn vehicles – a scene replicated in our 2012 shot, though the seamen have been replaced by tourists and the sailing boats are now represented by motor craft.

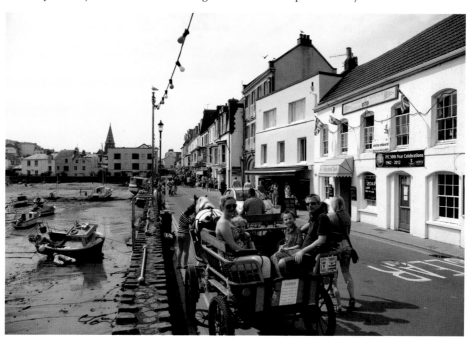

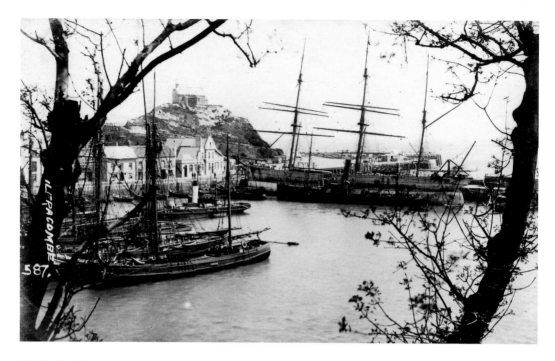

Sheltering from a Storm

We couldn't resist this wonderful 1913 shot of the harbour packed with sail and steam boats, possibly sheltering from a storm in the Bristol Channel. Tom Bartlett, who owns the original, suggests the three-masted vessel is probably the largest ship to ever tie up at Ilfracombe, and we agree. The array of boats in today's photograph shows the continuing pivotal importance of the harbour to the town.

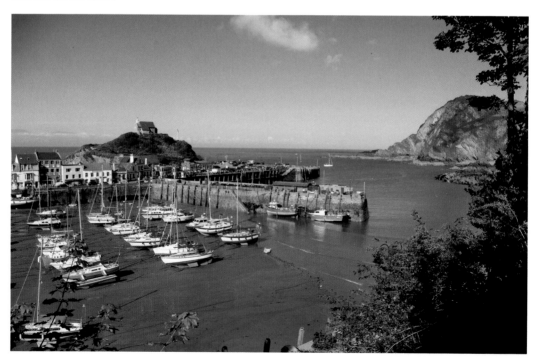

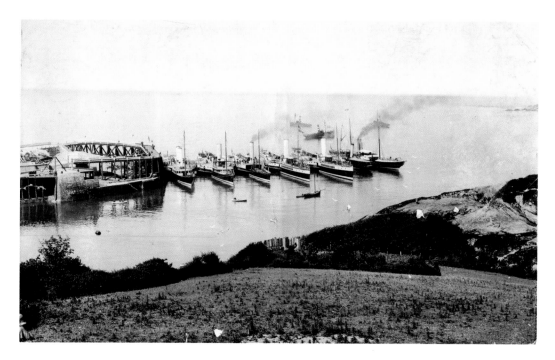

Paddle Steamers

Trippers didn't just arrive by train; they also came in their thousands on the paddle steamers of the P&A Campbell Company who dominated the Bristol Channel trade from around the 1880s up until 1981. As can be seen, passengers had to walk from one vessel to the next to disembark. Today's pier could almost be said to be naked without them!

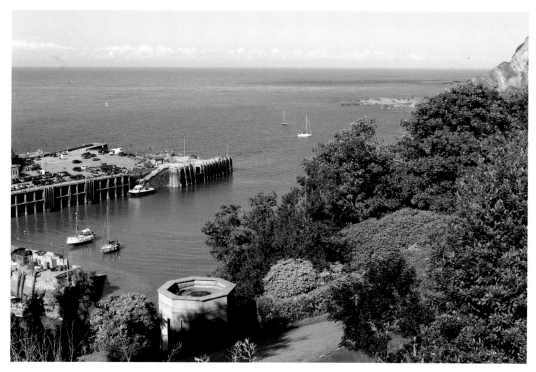

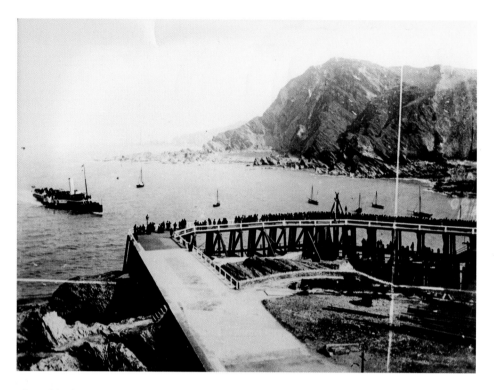

The *Oldenburg*

The massive changes experienced in the pier area are well illustrated in these two photographs. The first dates from around 1900 and shows one of P&A Campbell's steamers coming in to tie up at the pier. The modern one has the *Oldenburg* present plus a rather incongruous temporary stage playing host to a rock group.

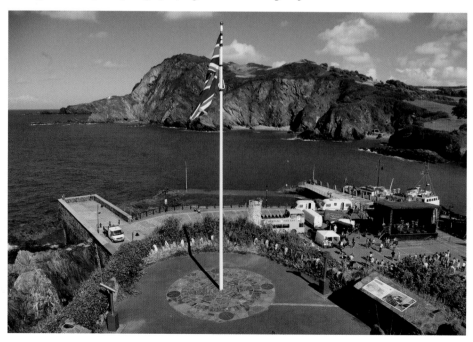

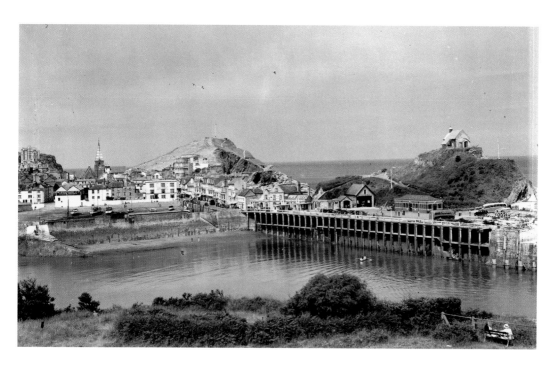

Water, Hills and Fascinating Architecture

One can see from these two shots, taken some sixty years apart, why Ilfracombe became the premier tourist resort in North Devon – the combination of water, hills and fascinating architecture was always going to be a winner. To the left in both is the banded slate patterning on the spire of St Philip & St James's church ('Pip & Jim'). Taking six years to build, it opened in 1857. The architect was John Hayward who also designed the Royal Albert Museum in Exeter.

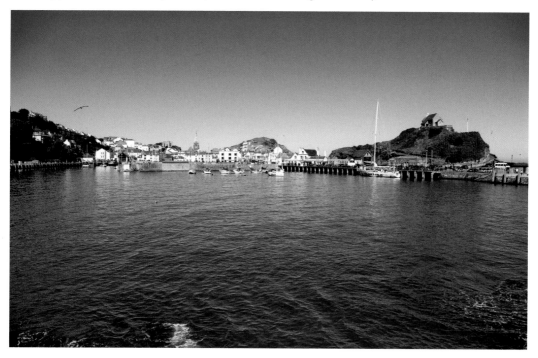

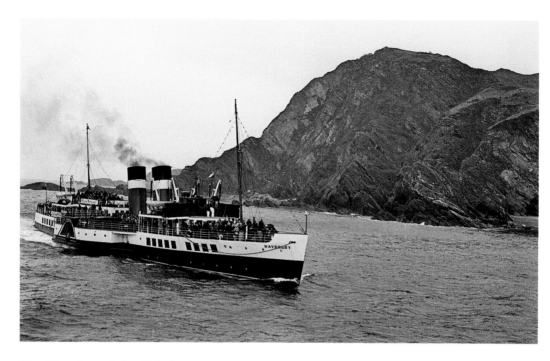

The *Waverley* and the *Oldenburg*

The *Waverley* paddle steamer is caught here arriving with tourists at Ilfracombe in June 1979. Our 2012 photograph shows the Lundy supply boat *Oldenburg* arriving back from a trip to the island and clearly shows the continuing importance of Ilfracombe harbour and the town's tourist trade. For the contemporary photograph the ship's captain slowed the vessel down and announced to the passengers and crew to wave to our photographer who was waiting on the pier!

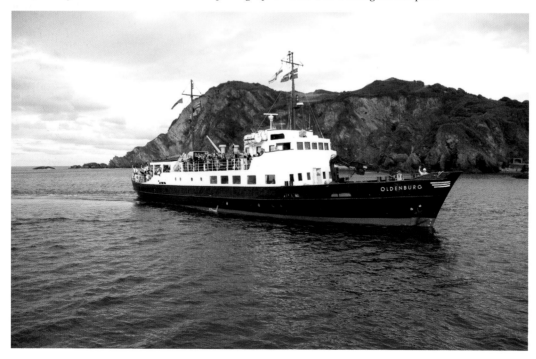

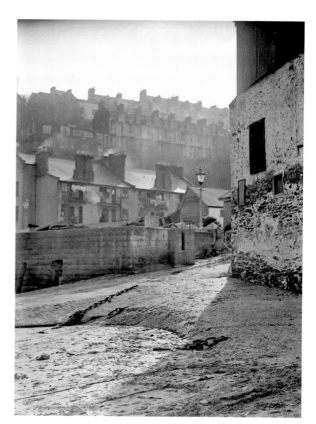

The Harbour II

This very atmospheric early 1950s shot of part of the harbour shows a town using coal fires in some rather decayed buildings. Some sixty years later the whole area looks more spruce and cleaner even if some of the original period attractiveness has gone.

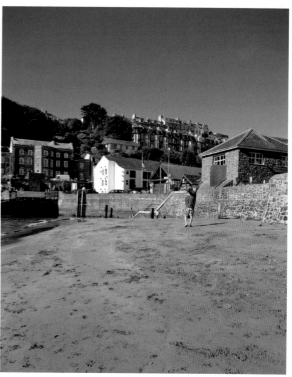

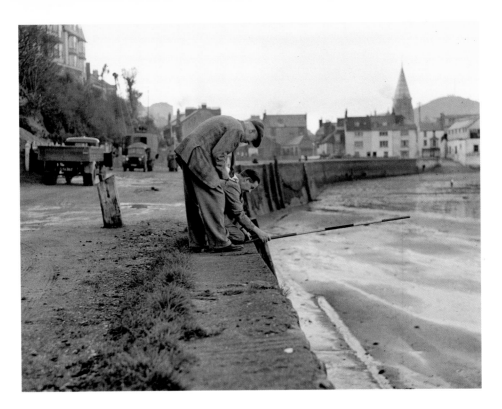

'Men from the Council'

The 1953 photograph shows two 'men from the council' measuring the harbour wall prior to rebuilding. The second shows today's harbourside with a Bideford trawler landing fish, and a crowd standing watching the catch being unloaded – always an attraction for the public.

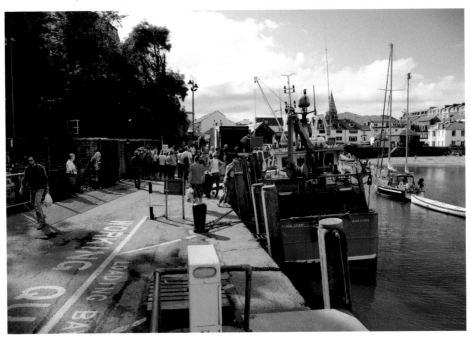

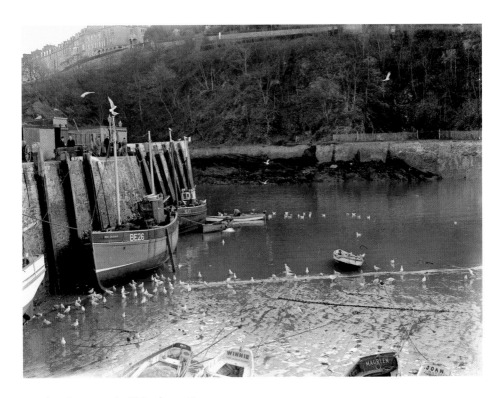

Rowing Boats and a Telephone Box

Two shots of part of the harbour exactly sixty years apart. In the earlier one the rowing boats have period names, such as *Winnie, Maureen, Joan*, whilst the fishing boat is *Deo Gratias*. The vessels in the modern photograph are much sleeker. The red telephone box is still here, some 116 years after the National Telephone Company established the first telephone exchange in the town.

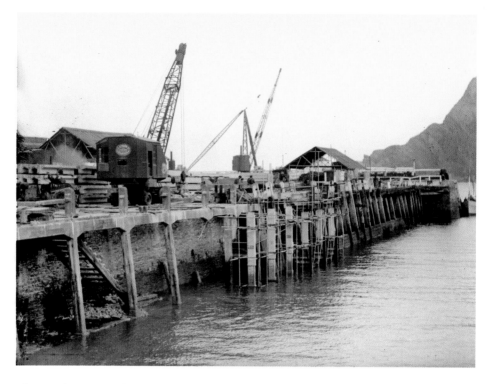

The South West Bird Man

The Ilfracombe pier actually dates from 1873 when a timber one was built at the mouth of the harbour. Over the years it slowly deteriorated. In 1952 the pier was largely rebuilt – the reconstruction work is shown in the photograph above. Our modern photograph was taken in August 2012 and shows the 'South West Bird Man Competition' where brave/foolhardy entrants try to 'fly', much to the amusement of the crowds of onlookers.

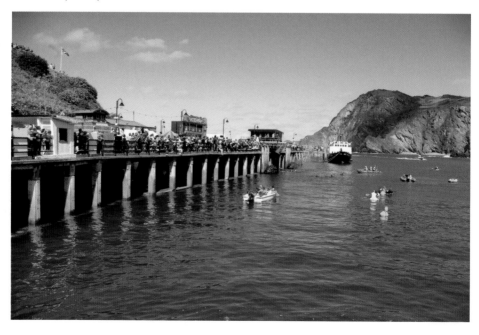

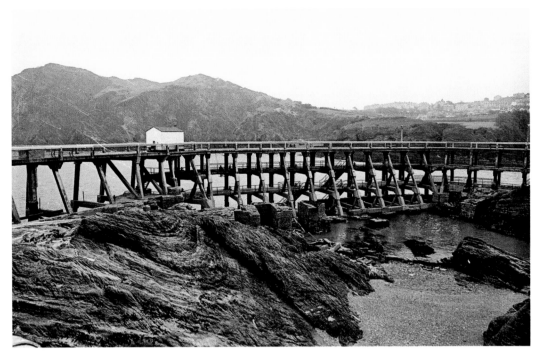

The Coast II

A panoramic shot of part of the rocky coast enclosed by the pier. The first picture dates from January 1975 and shows the 1952 reconstruction, whilst the second shot shows the later, much more substantial rebuilding.

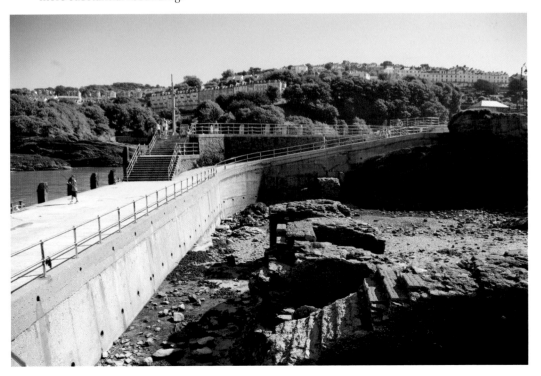

The Pier

The deterioration of the pier in the twentieth century is clearly seen in this unusual view from the early 1970s. Eventually the structure was completely rebuilt at great expense, though it has left the iconic structure ready to face the twenty-first century.

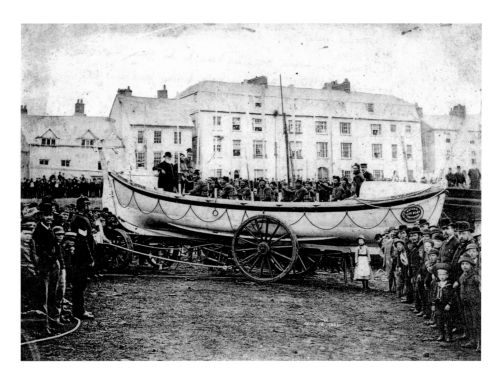

Lifeboats I

The lifeboats in Ilfracombe harbour – some 126 years apart. The 1886 shot shows the then brand-new *Co-operator No. 2*, which was credited with saving four lives. The buildings in the background are still recognisable in part even if rebuilding has changed the scene considerably, whilst today a powerful tractor has replaced the horses and manpower used to haul the boat up the beach prior to its return to the boathouse.

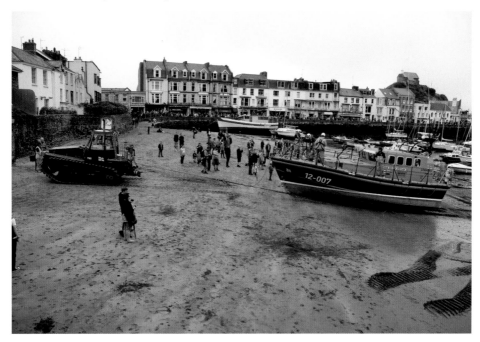

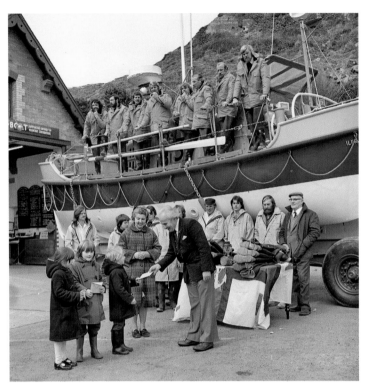

Lifeboats II
Ilfracombe has had a lifeboat since 1828 and it always attracts visitors. The photograph above dates from April 1979 and shows staff and students of Ilfracombe Infants School handing over money they had raised for the RNLI to the local branch secretary Les Boyles. The second proves that the lifeboat still draws a huge crowd, and we even got the town crier Roy Goodwin to join the group in his full ceremonial dress on the annual 'Rescue Day'.

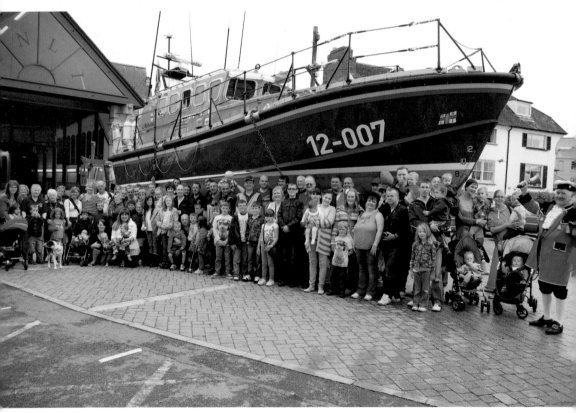

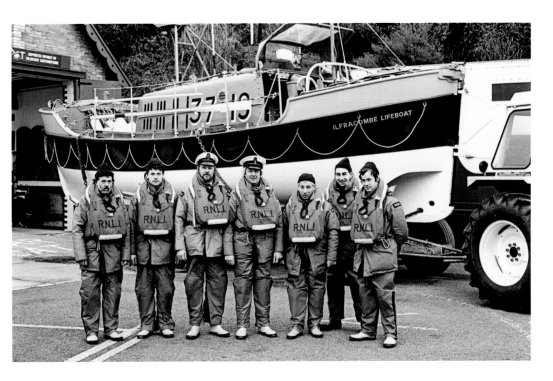

Lifeboats III

Ilfracombe is immensely proud of its RNLI lifeboat, and its crew of volunteers are shown in these two photographs. The first from December 1984 features, left to right: Morris Woodger, Dave Paul Clemence, Wayland Smith, David Clemence, Colin Thadwell, Andrew Bengey and John Fennell. The 2012 shot shows Mark Weeks, Andy Maslen, Carl Perrin, Johnathan Davies, Ben Langham, Andrew Bengey (now the coxswain) and Alex Welch.

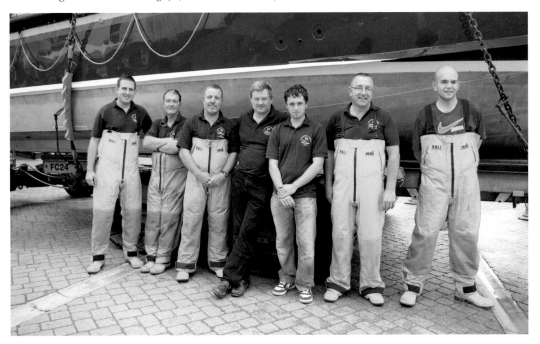

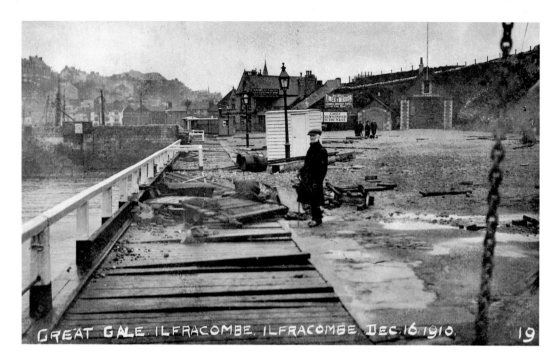

GREAT GALE ILFRACOMBE. ILFRACOMBE. DEC.16.1910. 19

Atlantic Storms

North Devon is often subject to Atlantic storms, but few caused as much damage as this one in December 1910. A storm surge struck Ilfracombe harbour inflicting massive and very costly damage to the pier. The town council carried out repairs, and the pier, in a new incarnation, still provides a favourite promenade for locals and visitors alike.

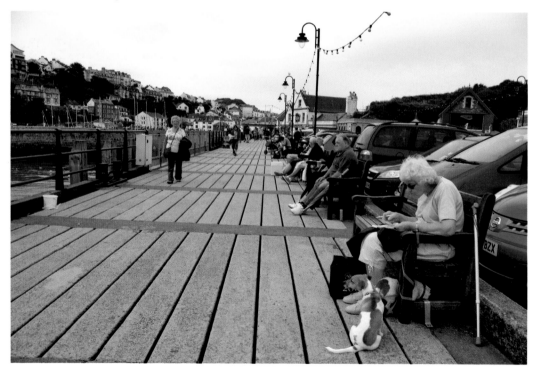

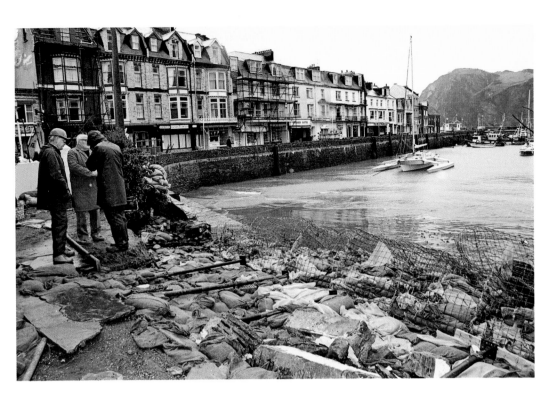

The Harbour Wall

In February 1990 another major storm hit Ilfracombe and the old harbour wall was badly damaged, as shown in our photograph. Work soon started on repairing the damage and strengthening the flood defences, without losing the attractiveness of the beach and harbour area in general – with some success as shown in our 2012 photograph.

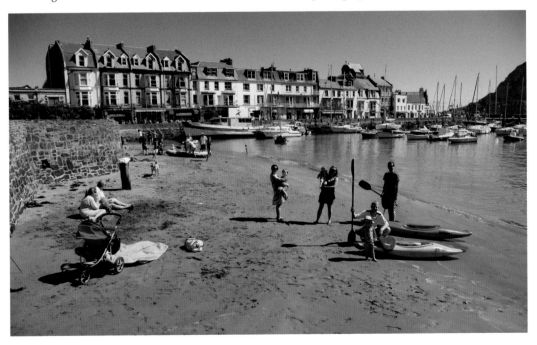

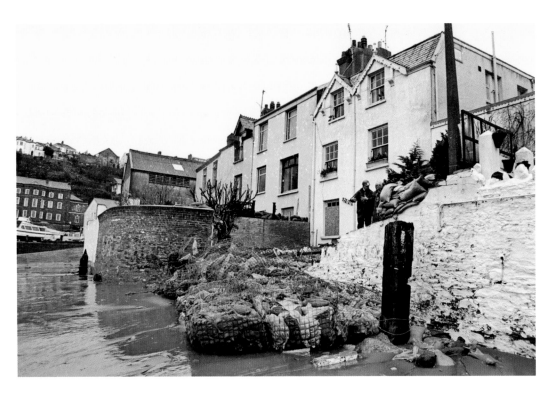

Emergency Flood Defences

Another shot of the damage, showing some of the emergency flood defences hastily put in place to reassure local residents; it is unrecognisable from the lovely beach scene captured in August 2012.

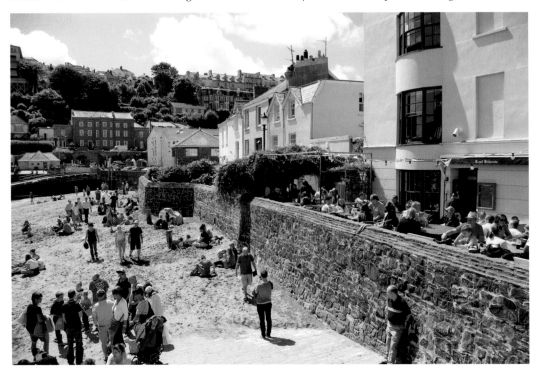

Boats in the Harbour

Ilfracombe harbour has always been a busy place, although today recreational vessels outnumber commercial ones. In our first photograph from around 1890, the *Ripple* yacht is passing the chapel of St Nicholas with a party of trippers aboard, including Mr Frank Tuck who, rather incongruously, is holding a rifle – though this may have been to start a boat race. Our 2012 photograph shows the much sleeker modern boats.

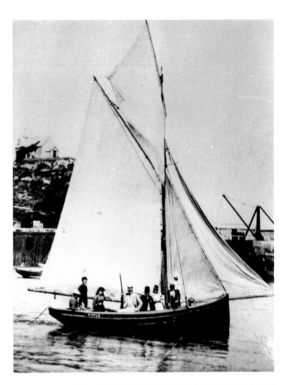

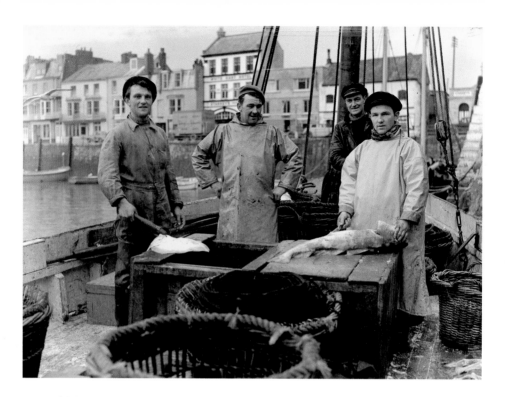

Gone Fishing

Although not as large as it once was the fishing industry still survives in Ilfracombe. Here from December 1952 we see four local fishermen on their vessel by the harbour wall. They were, from left to right: Clifford Barbeary, Douglas Barbeary, Percy Horell and Tom Barbeary – all of whom were employed on long-line fishing from their boat, the *Excellent*. Our modern photograph has no fishermen, but the buildings in the background are still recognisable.

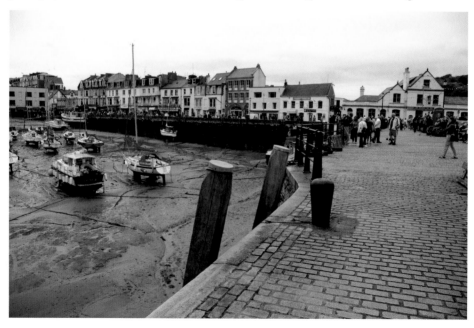

The Inner Harbour

The inner harbour crowded with pleasure craft in June 1984, with the chapel of St Nicholas prominent on the left. The 2012 photograph shows the lifeboat crew plus collection buckets on the annual 'Rescue Day' – a service those with pleasure boats rely on as their backup at sea.

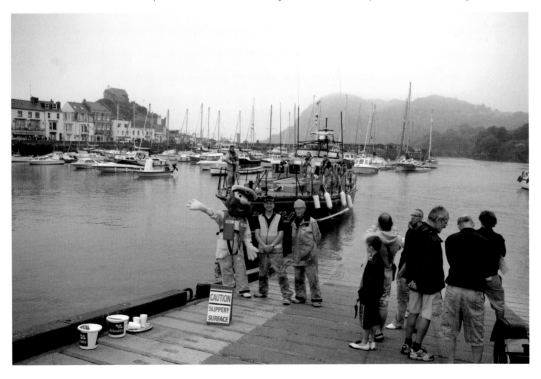

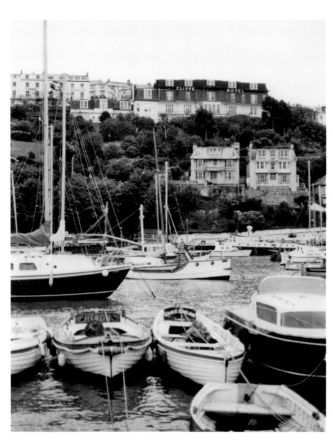

Benricks, St Agnes and the Cliffe Hotel
A peaceful but crowded-looking harbour in both shots: one from the 1960s and the other from 2012. The two large detached buildings, Benricks and St Agnes, are still there just above the harbour, but the old Cliffe Hotel has gone and has been replaced by a brand-new development of luxury flats.

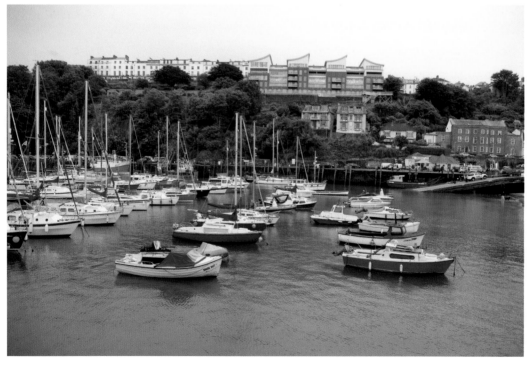

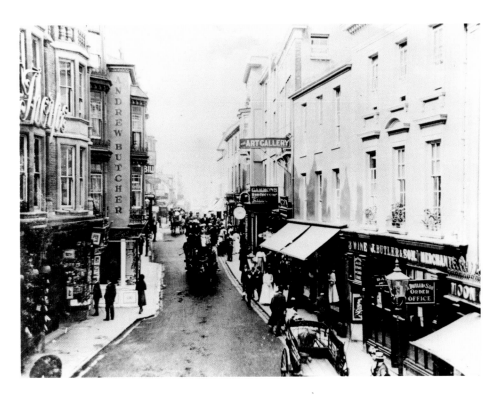

The High Street – Eastern End

Two views of the eastern end of the High Street. Our 'old' picture dates from around 1910 and shows a road as busy as today's, albeit without the road sign warning of overhanging buildings – no large articulated lorries back then, and certainly no need for the contemporary speed bumps in the road! Interestingly, today's St George pub was then the premises of J. Butler wine merchant – things change, but not that much.

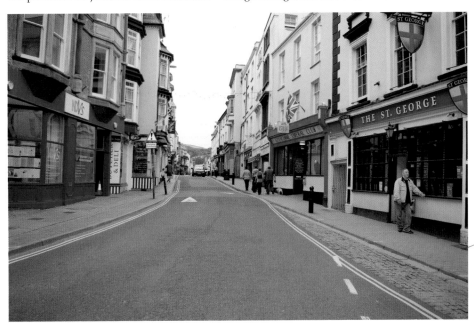

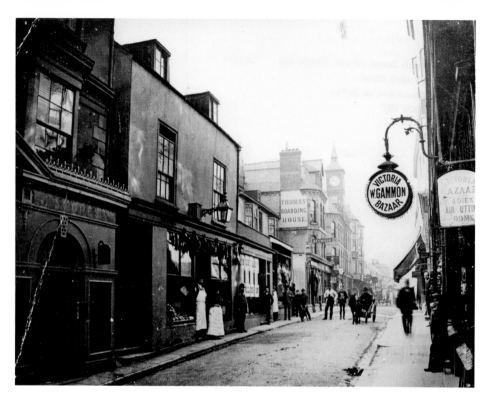

The High Street Clock

Another section of the High Street with the prominent clock which was made by Smith & Son of London. Its erection was completed in May 1874 under the supervision of local clockmaker Mr Thomas. The photograph dates from around 1890 and compares well with our 2012 shot, with its yellow lines and lack of extravagant looking gas lamps.

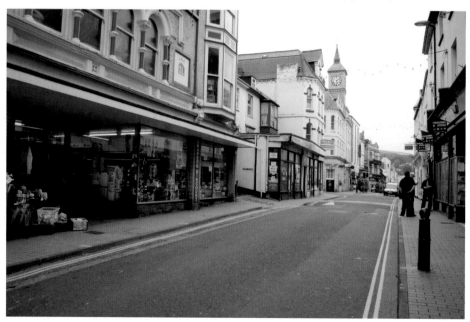

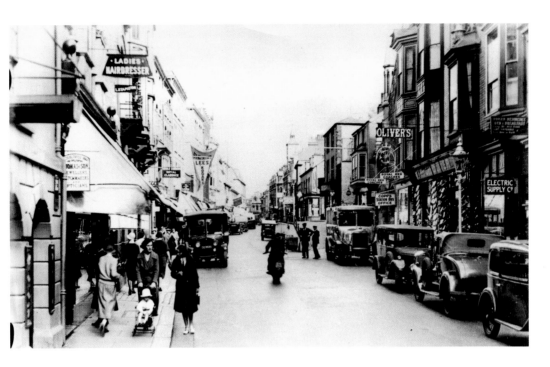

The Bunch of Grapes

The arches of the Bunch of Grapes in the High Street to the left of both photographs allow us to compare these two very different shots. The 1930s photograph with its wonderful display of sturdy looking cars is very different from the same view taken when the 2012 carnival was traversing the road. The disappearance of so many of the older signs and banners is very evident.

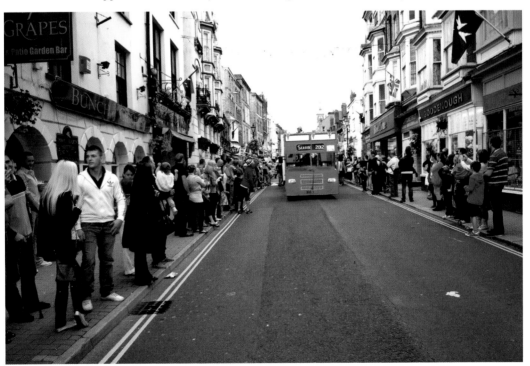

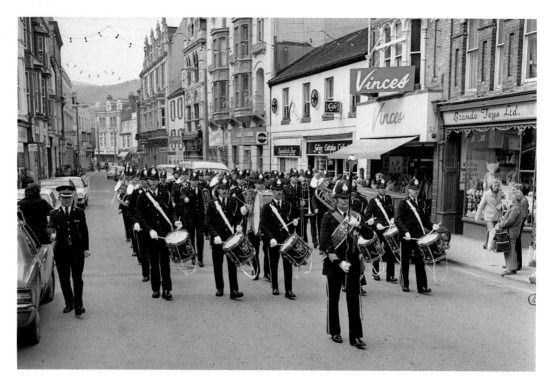

The High Street – Police Parade I

Ilfracombe High Street is the widest thoroughfare in town, so its use for displays isn't surprising. In the March 1980 shot above we see the band of the Devon & Cornwall Police parading, whilst our 2012 shot shows the same buildings with the same cartwheels on the café and even what looks like the same fancy light bulbs strung across the street. Continuity or what?

The High Street – Police Parade II A companion photograph to the previous shot, only this time the police band is caught passing the Lantern in High Street. The building began life in 1728 as an Independent chapel, though it was rebuilt in 1819, 1834 and 1886. Today it provides a community centre, and note how all the shops have changed and a new pedestrian crossing has been set up.

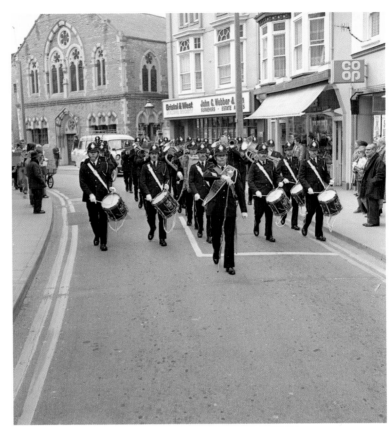

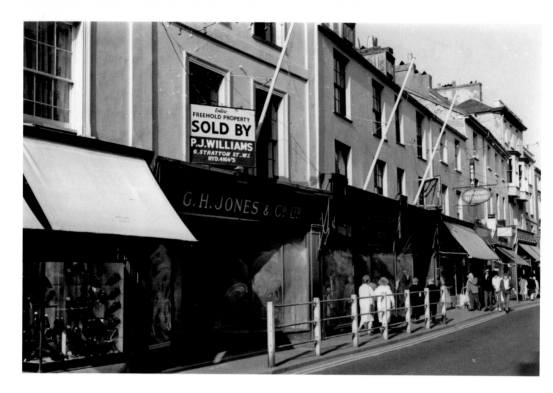

The High Street Shops

Part of Ilfracombe High Street in the mid-1960s and in 2012. The shopfronts have been modernised but above them the frontages are still remarkably similar. The shops themselves reflect the new Britain with a mix of organic food, a Tandoori restaurant and, of course, a charity shop. Our earlier shot shows the premises of G. H. Jones, a prominent local store.

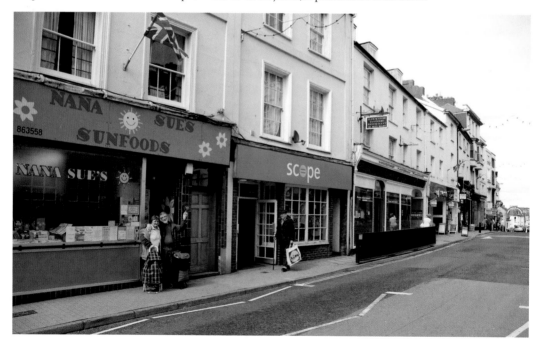

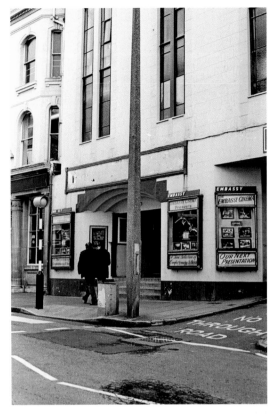

Films in Ilfracombe

Ilfracombe was the first place in North Devon to see moving films – in May 1897 when a 75-foot-long film was shown in the town hall by one Charles Hopward – with the town being used as the backdrop by a film crew only a few years later in 1912. The Embassy cinema in High Street is shown above in March 1983 and below as it is today; it opened in October 1948 and still supplies both locals and visitors with a big screen venue.

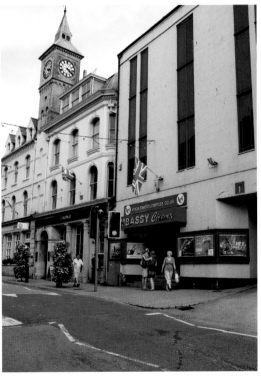

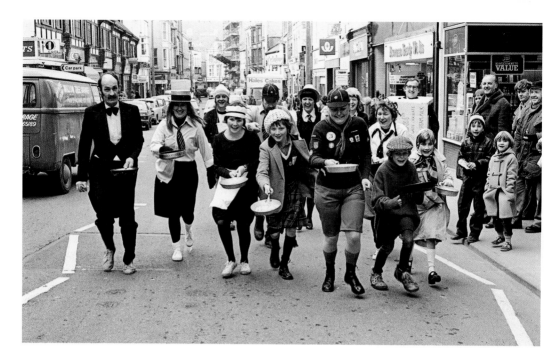

Pancake Races I

Ilfracombe had a nice tradition of staging pancake races in the High Street, which were very photogenic with photographs of the participants also capturing the buildings in the background. This pancake race was staged in February 1983 and since then many of the shops have changed hands, with Woolworth's being a notable loss. Such changes have been a common occurrence over the last century with many once prominent names having disappeared.

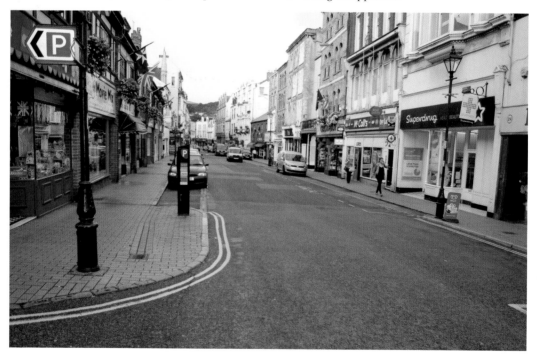

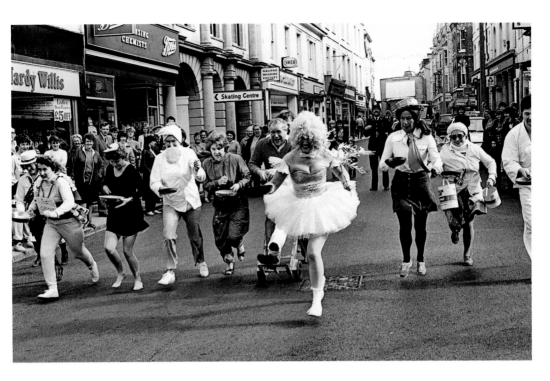

Pancake Races II

This shot from March 1984 shows that year's pancake race when it is clear that fancy dress wasn't optional! The 2012 view shows the town crier Roy Goodwin and his wife Bee leading the carnival with the Bideford Pipe Band following them.

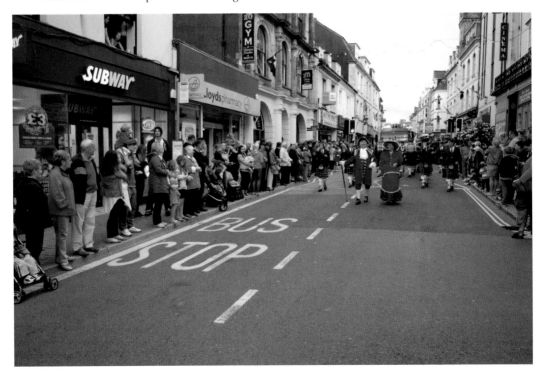

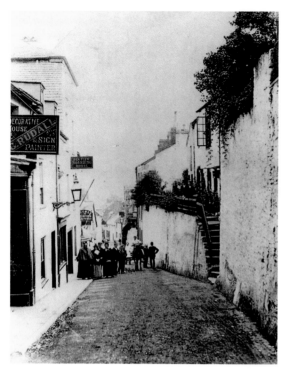

Fore Street I
Only the steps seem to be the same in these two photographs, separated by some 115 years. Fore Street has always been a busy thoroughfare leading down as it does to the harbour, even if horses don't often traverse it today.

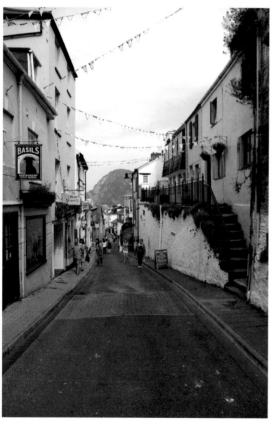

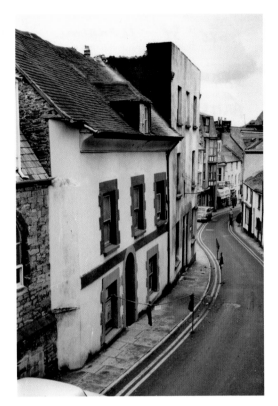

Fore Street II

Fore Street has always been a very atmospheric road, yet even here the scene has changed greatly over the years. Here, from October 1966, we see part of the street at the time of the demolition of the old Ebrington Arms, and from 2012 the replacement houses plus the new pavement and bollards.

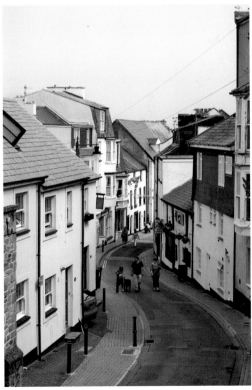

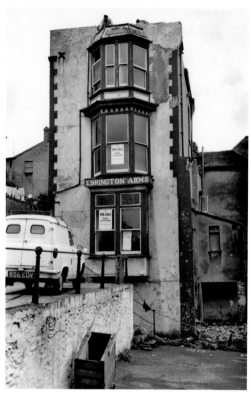

The Ebrington Arms
The vista that was opened up following the demolition of the Ebrington Arms is shown in our modern photograph, with a close up of the old pub just prior to its demolition. The name came from one of the titles borne by Earl Fortescue and his descendants, a noted North Devon family.

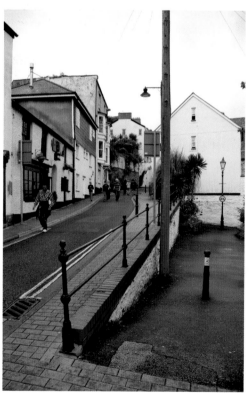

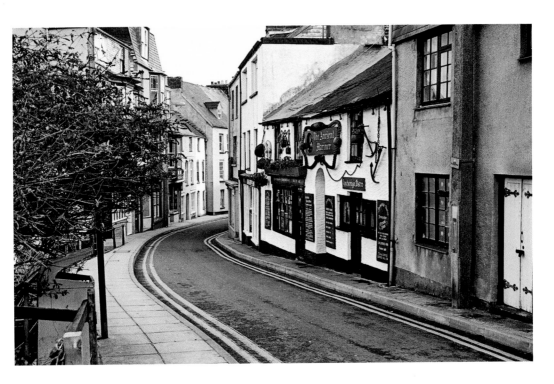

Restaurants and Pubs

Restaurants and pubs may change their name but the buildings often remain the same. In the October 1983 photograph the very distinctive Ancient Mariner bistro is decorated with anchors, ropes and maritime paraphernalia – rather different from the same restaurant twenty-nine years later.

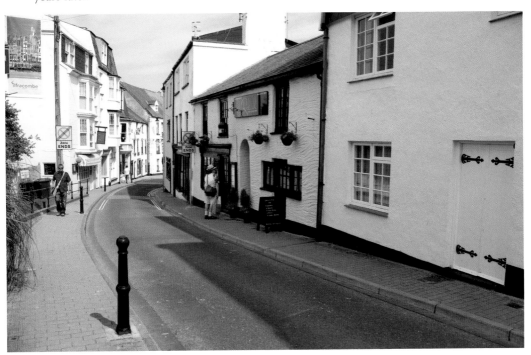

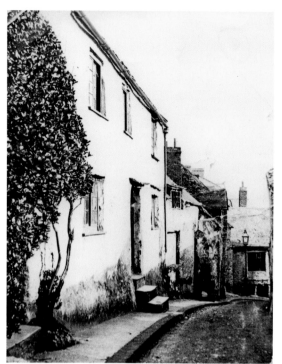

Capstone Road
The photograph above probably dates from around 1880 and shows just how bad some of the old houses in Ilfracombe were, this being Capstone Road looking down to the modern Sandpiper Inn. The same view today can only be recognised by the steepness of the road and the sharpness of the corner.

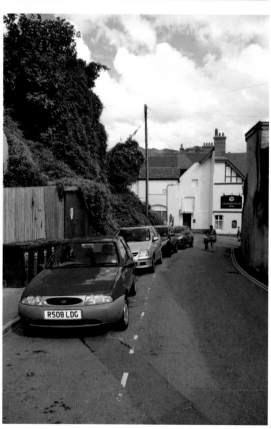

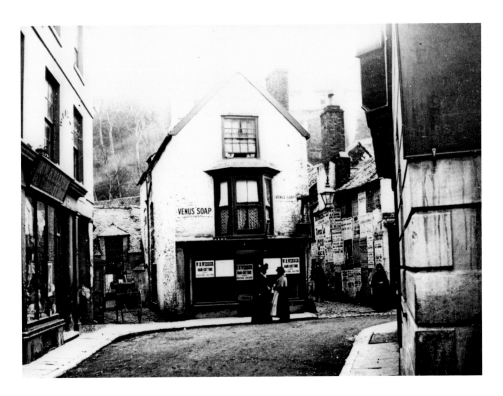

Broad Street/Fore Street Junction

The junction of Broad and Fore Streets is shown here demonstrating just how much can change in the 120 years between when the photographs were taken. The three-storey building in the centre was demolished to widen the road and the whole area looks a lot more salubrious than it once did.

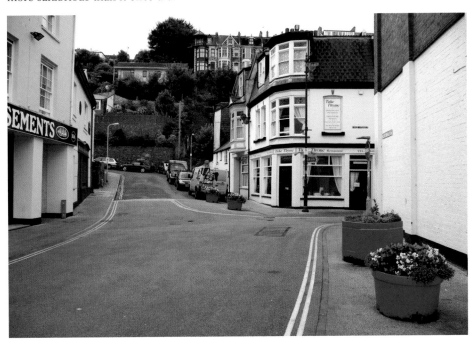

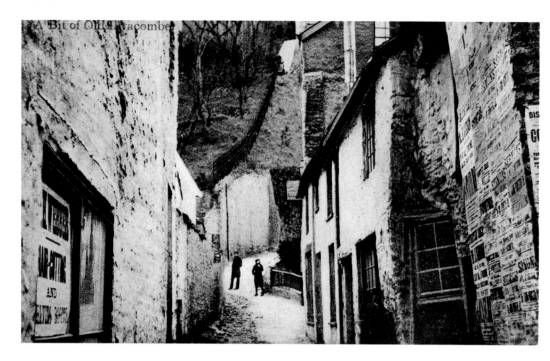

Quayfield Road

This locally published postcard dates from around 1900 and shows the narrow passageway in the background of the previous picture, leading from the bottom of Fore Street up towards Coronation Terrace, with some very small and run-down cottages in the picture. Today the passage has been widened into Quayfield Road and new buildings erected – not so picturesque perhaps but almost certainly healthier.

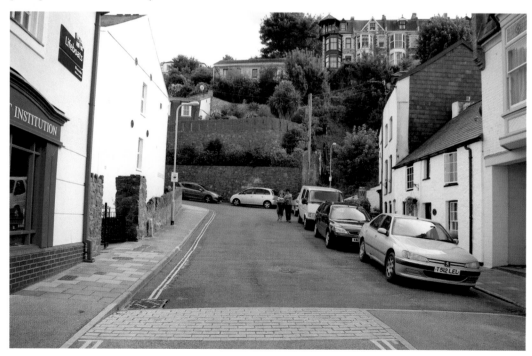

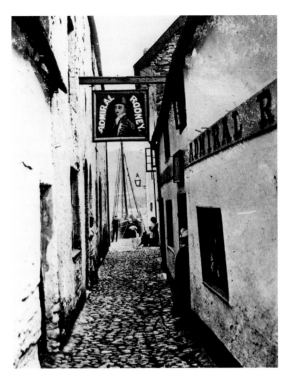

Admiral Rodney Inn

The name of the Admiral Rodney Inn harks back to a very successful late-eighteenth-century Admiral who, in his illustrious career, managed to destroy both Spanish and French fleets. Today the harbour can still be glimpsed at the end of the alley, but how bland the twenty-first-century view is compared to the Victorian one, although the ship on the fascia seems to be a nod to history, given that the inn disappeared in 1915.

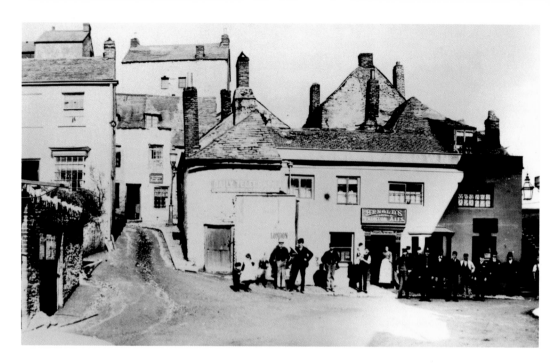

The Crown Inn

Not many of our photographs show such a dramatic change as this. The Crown Inn shown around 1890 was a very old-fashioned-looking pub owned by Arnold's Brewery in Taunton. As Ilfracombe expanded, so many of its buildings, including this one, were replaced, and the very solid-looking Sandpiper Inn now stands on the site.

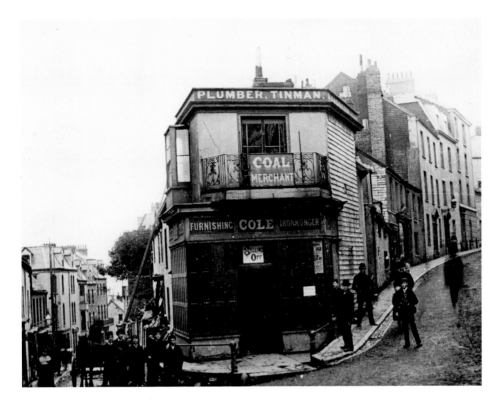

Fore Street/Portland Street Junction

The rather 'thin' building sandwiched into the junction between Fore Street and Portland Street is shown here from around 1890 when a Mr Cole was running a few businesses from it – coal merchant, plumber, tinman, furnishings and ironmongery! Given the constricted nature of the site the only way to grow was upwards as seen in our modern photograph.

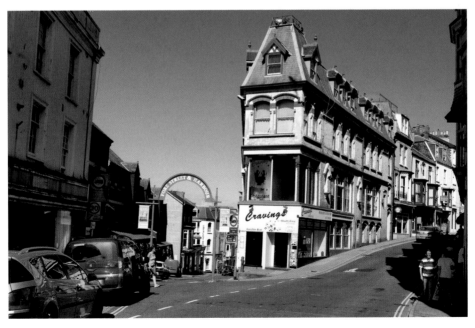

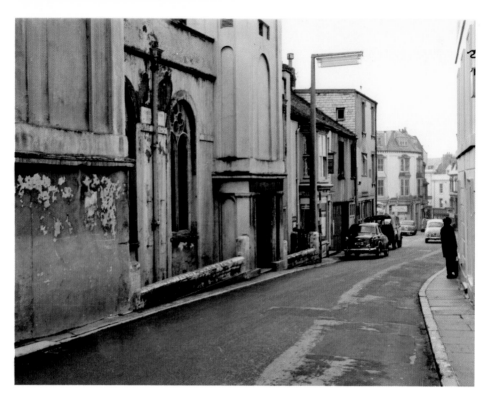

Portland Street I

What a contrast between these two photographs. Portland Street in the 1960s was a rather grim-looking entrance to Ilfracombe, yet following demolition and planting the road now appears inviting and very colourful.

Portland Street II

Another example of how much some parts of Ilfracombe have changed. The top of Portland Street was hemmed in so that when the opportunity arose, the Castle Hotel and adjoining buildings were demolished to create a wider road, with a splash of vivid colour from new trees and bushes.

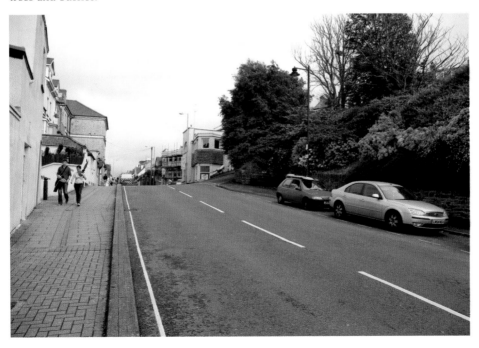

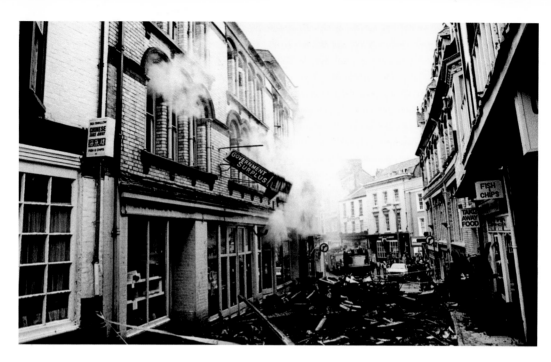

Fires I

Ilfracombe has a sad history of fires, yet it always bounces back. The fire above occurred in December 1981 in a 'Government Surplus' store in Portland Street and, even though it caused a great deal of damage, the buildings were refurbished and brought back into use as shown in the second photograph.

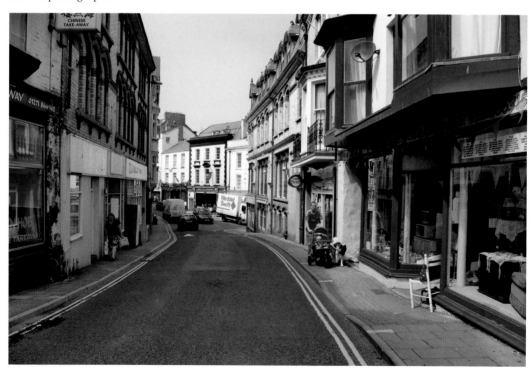

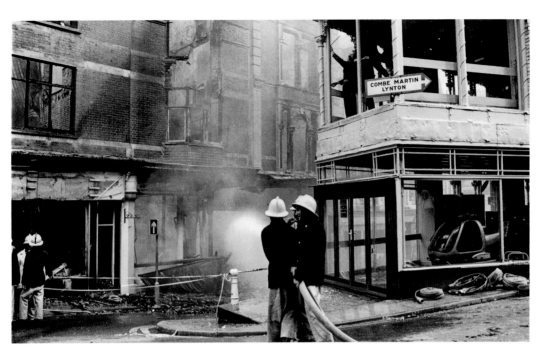

Fires II

The junction of Fore Street and Portland Street has seen a few major conflagrations over the years including this one from August 1983. The burnt-out buildings were eventually rebuilt as part of the new Candar development – though the ornamental metal pillars on Cravings are an attractive survival from an earlier period.

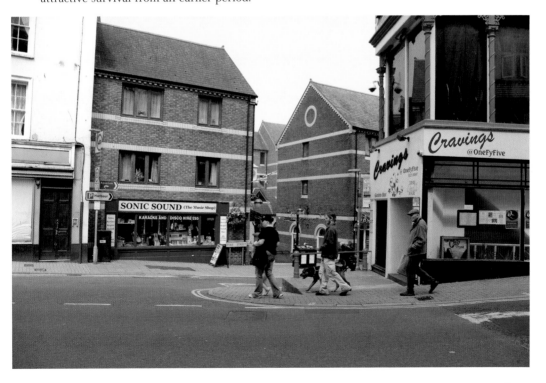

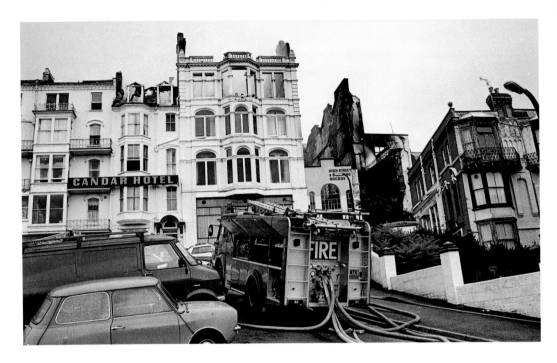

Fires III

This particular fire led to some dramatic changes as shown in these two photographs. The first shows the fire brigade attending the conflagration shown in the previous photograph but from a different viewpoint. The site was later cleared and replaced by the very attractive new Candar development shown here, complete with a 'blue plaque' recording that 'On this site stood the Ilfracombe Arcade'.

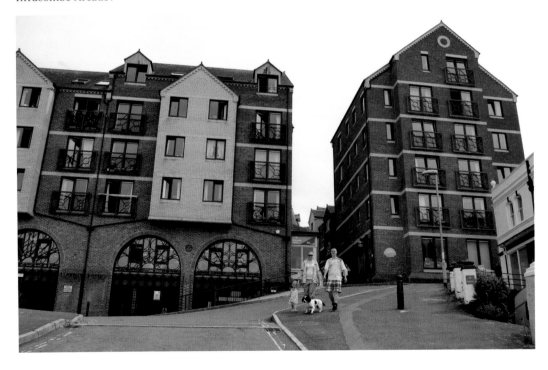

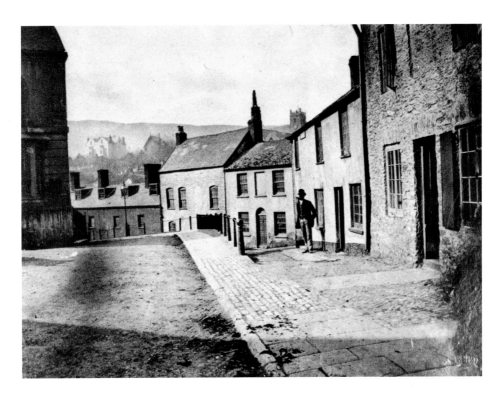

Church Street I

The photograph above is one of the earliest in this book having been taken around 1870. It shows the top of Church Street and, as might be expected, it looks very different nearly 150 years later. All of the buildings have been rebuilt whilst the road surface has been lowered. One wonders what the man in the original photograph would have made of these changes?

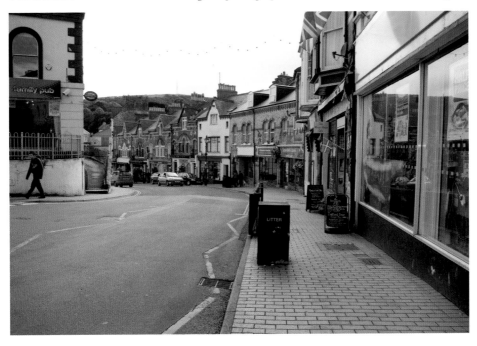

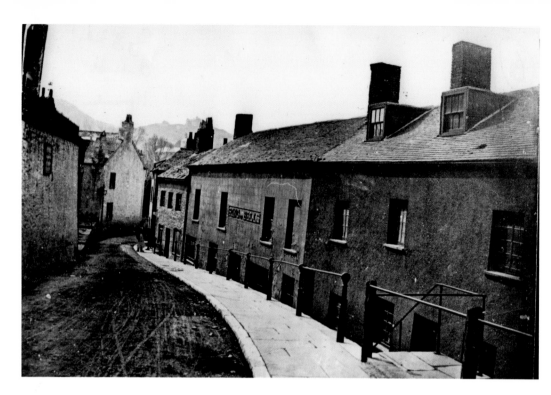

Church Street II

A bit further on down Church Street and although the general shape of the road is recognisable every other detail has changed as with the previous shot. Renewal on such a large scale is clearly not just a twentieth-century phenomenon.

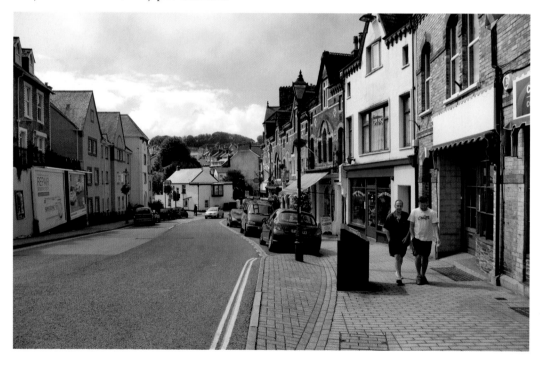

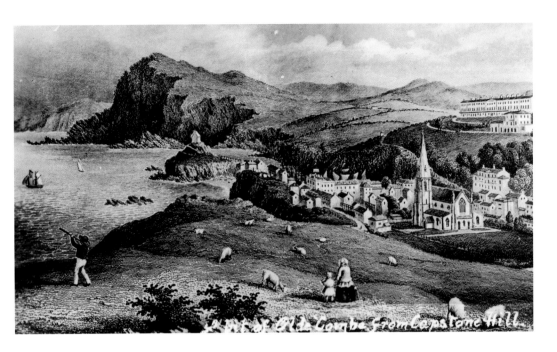

No Sheep on the Capstone

According to Tom Bartlett, the doyen of North Devon postcard collectors, this card is one of a series produced around 1908 using old prints originally published in 1830. The church of St Philip & St James is prominent, as is Hillsborough Terrace to the right. Our modern view shows the church now rather hemmed in by later buildings – and no sheep on the Capstone.

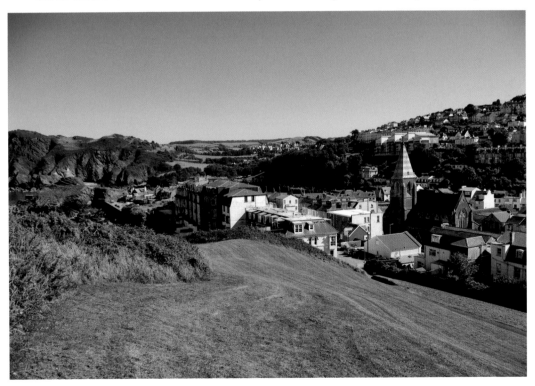

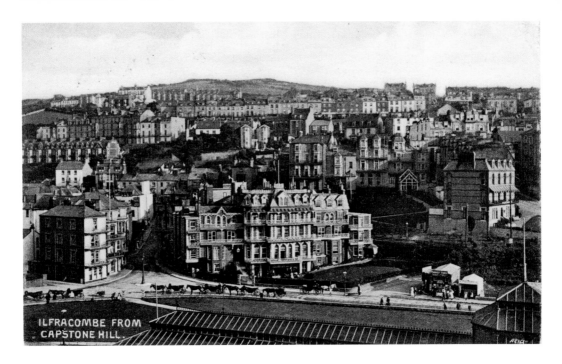

The Collingwood Hotel I

Climbing Capstone Hill a century ago would have presented this view of rank upon rank of housing ascending the hill behind the harbour. The Collingwood Hotel began life as a terrace of houses before being rebuilt around the mid-1880s to form the grand hotel building, which was later extended on both sides. It was demolished in January 2012 following 140 years ownership by the Challacombe family, and the site purchased by J. D. Wetherspoon for redevelopment.

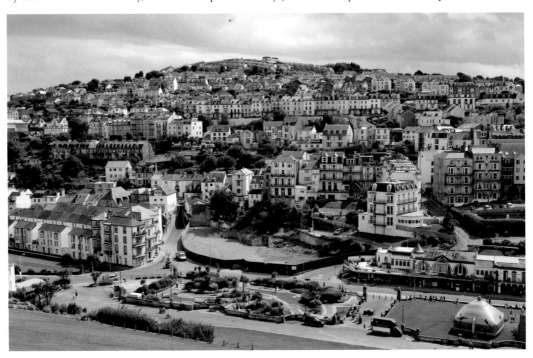

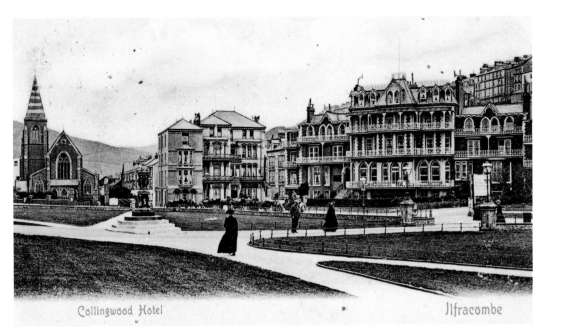

Collingwood Hotel Ilfracombe

The Collingwood Hotel II
Another view of the Collingwood Hotel, this time from the ground level, showing the ornate railings on the balconies that were such a feature of the building. The formal gardens in front are now rather more exotic and one wonders what the Victorians would have made of today's bouncy castle?

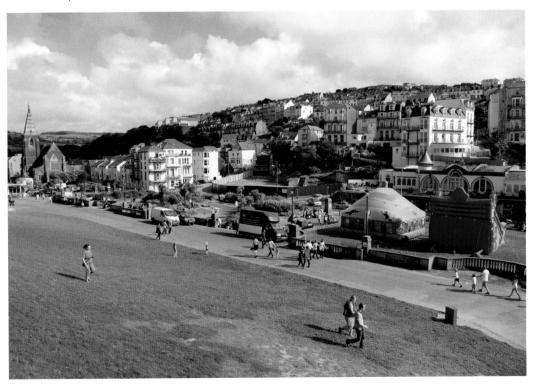

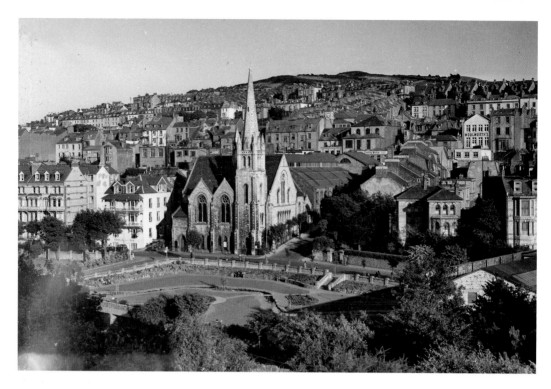

Emmanuel Church

One of the most memorable views of the town. Both photographs, from 1951 and 2012 respectively, are dominated by Emmanuel Church in Wilder Road. Designed in the Gothic style by W. H. Gould for the Methodists, it was opened in 1898 having been built in just ten months.

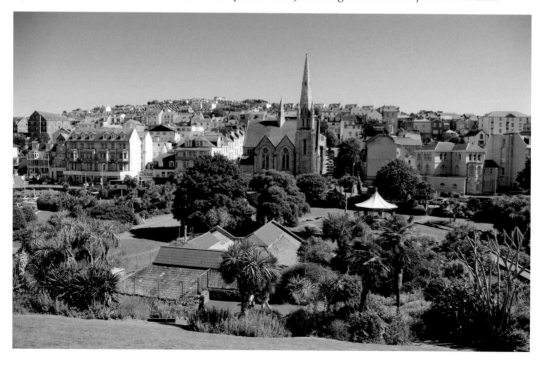

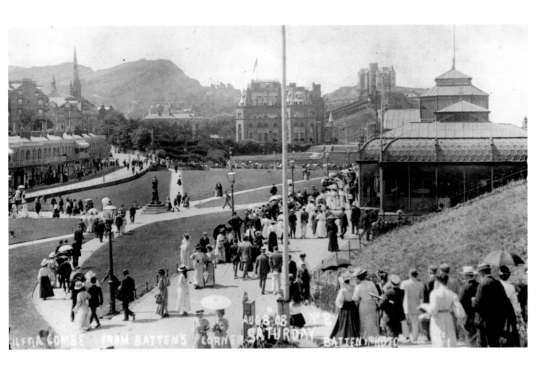

Ilfracombe Seafront

These two views of Ilfracombe seafront capture the beauty of the town's situation surrounded as it is by green hills. The Promenade of shops just behind the bouncy castle in our modern shot dates from 1880, being described in 1937 as having 'a distinctly superior tone about it', though only two storeys were allowed so that the hotels behind didn't lose their views.

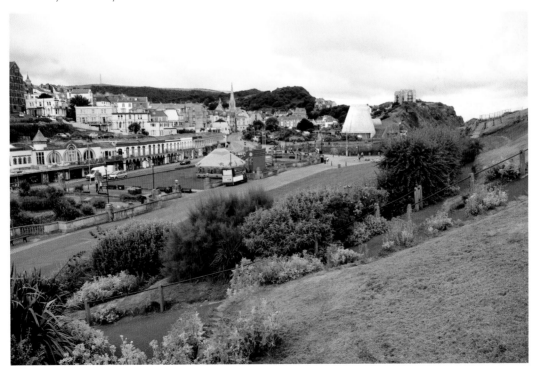

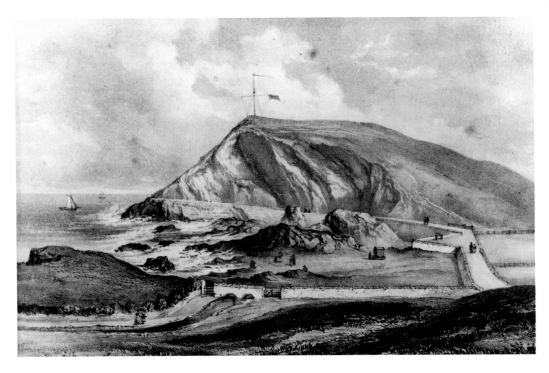

Capstone Parade I
This old print records the opening of the Capstone Parade in 1843, when the view consisted of just the walkway, some walls and one bathing machine (for changing in). Today the walkway is still obvious but a lot more development has taken place.

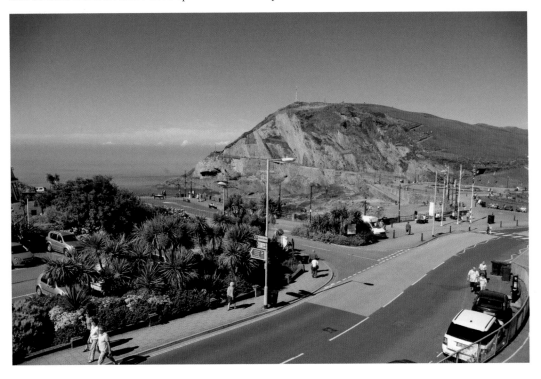

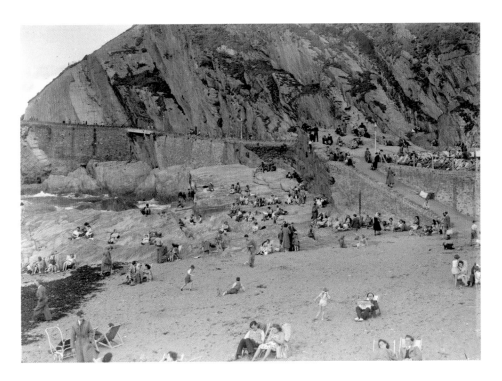

The Capstone I

The Capstone looms large in Ilfracombe's history providing a spectacular viewpoint over the town if you can make the climb up the zigzag pathway (opened in April 1894). The Parade at the foot of the hill dates from September 1843 as noted on the previous page. The funds to do it were raised by a subscription from local townspeople. Its opening was celebrated with a regatta and some might say this marked the start of the mass tourist industry in the town.

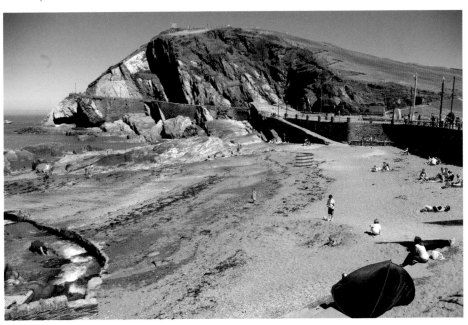

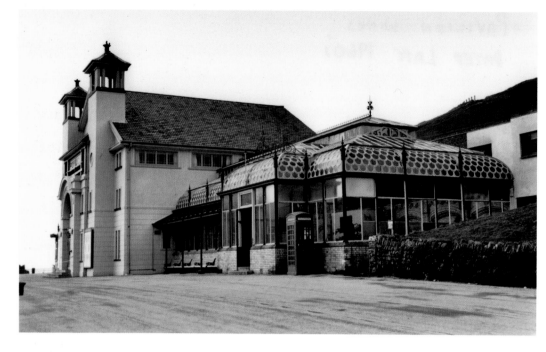

The Victoria Pavilion

The Victoria Pavilion was opened in 1888 on the lower slope of Capstone and was largely rebuilt following a disastrous fire in 1949. It had acted as a theatre for visiting acts for many years but became too costly to repair. Demolition was agreed on in 1992 and the open area seen in the second photograph was created.

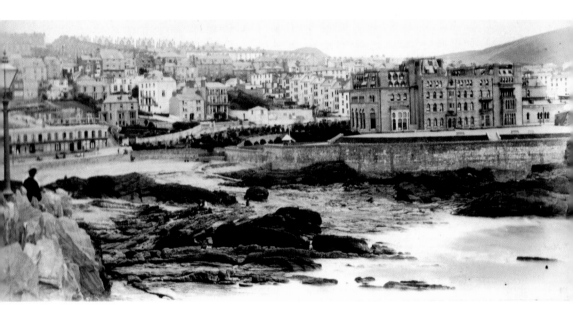

The Ilfracombe Hotel I

The Ilfracombe Hotel was the last word in Victorian luxury, being opened in May 1867. It had been built by a new company, the Ilfracombe Hotel and Esplanade Company, in a 'French Gothic' style to designs by Mr Horne, a London architect. The massive sea wall around the site is seen in both photographs, which have been taken from different angles.

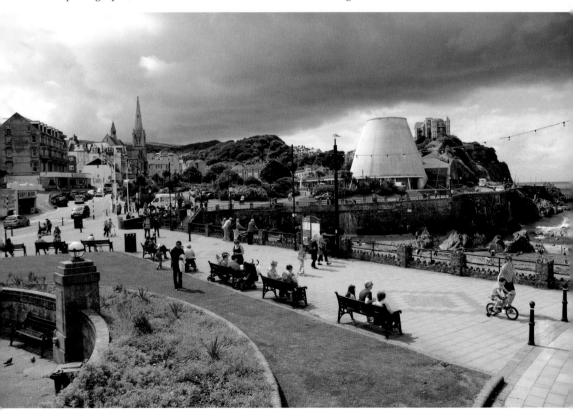

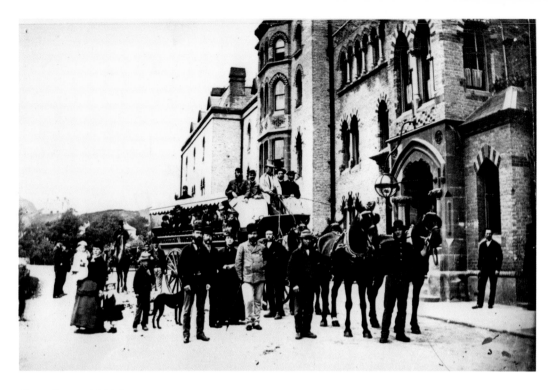

Horse-Drawn Vehicles

Visitors would have used horse-drawn vehicles to get around, as shown in this charming photograph from around 1880. Our modern shot shows the same view today – no horses but still plenty of visitors.

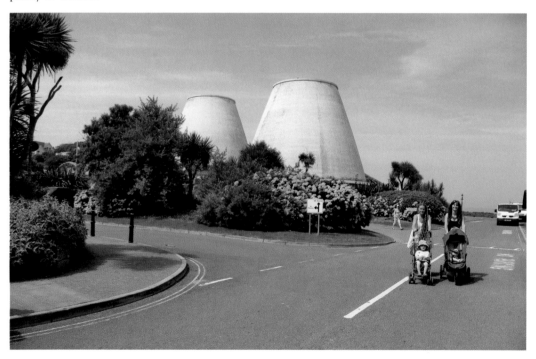

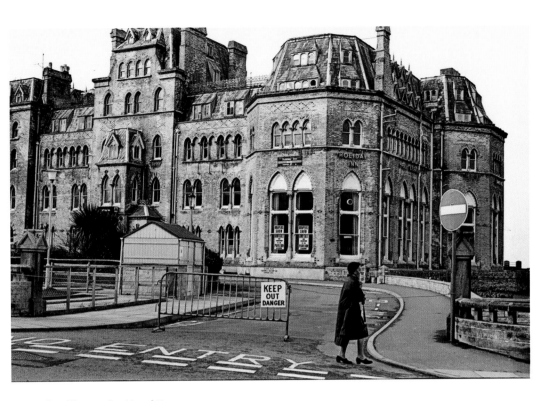

The Ilfracombe Hotel II
Another shot of the Ilfracombe Hotel just before demolition showing what an amazing building it was. Today's view shows the Landmark Theatre, a contentious design that can still generate strong feelings in both detractors and supporters, though as a theatrical auditorium it is superb.

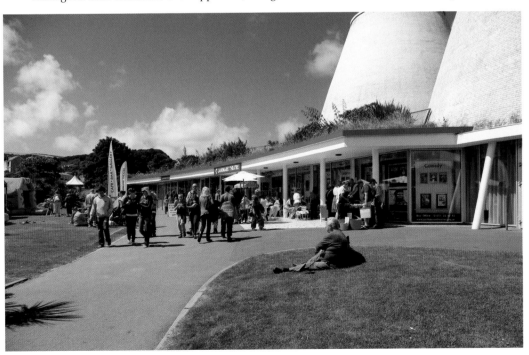

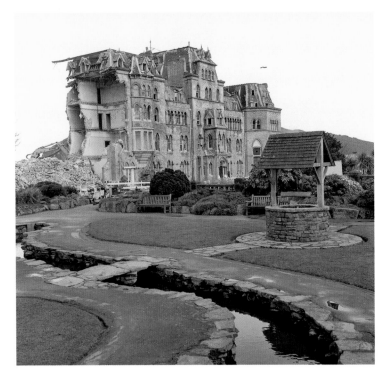

The Landmark Theatre

As time and changing tastes took their toll, the hotel ended up as council offices with the building finally being demolished as unsafe in 1976. Today the Landmark Theatre has taken its place and our modern photograph shows this behind the trees along with the wishing well (extreme right) and museum. The people are listening to members of the Blazing Sounds.

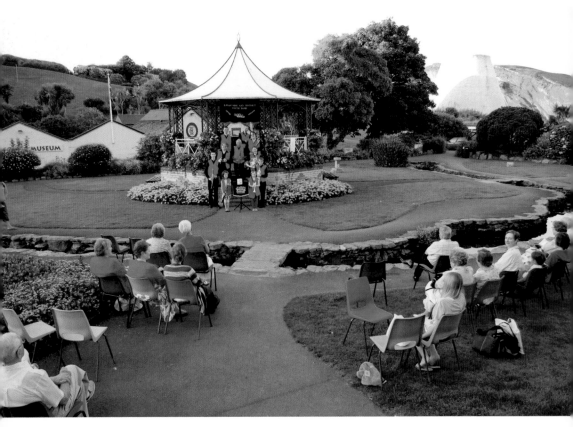

The Imperial Hotel
These photographs extend the view in front of the previous one. In the December 1976 shot the old Ilfracombe Hotel is being demolished, whilst the Imperial Hotel is on the right. This latter establishment was built in 1867 as two separate businesses – the Imperial Private Hotel on the East and the Waverley on the West – though they were later joined together under one owner.

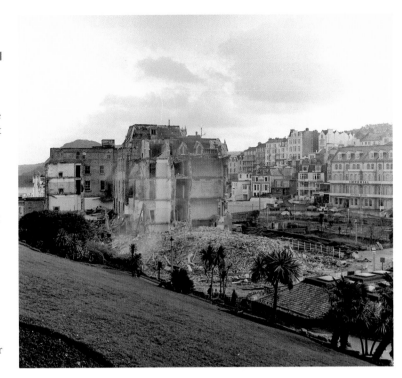

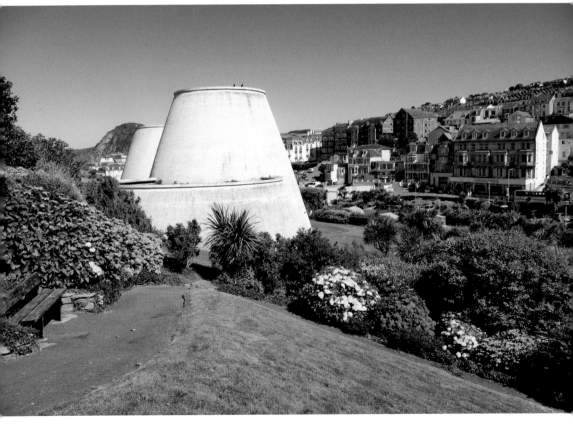

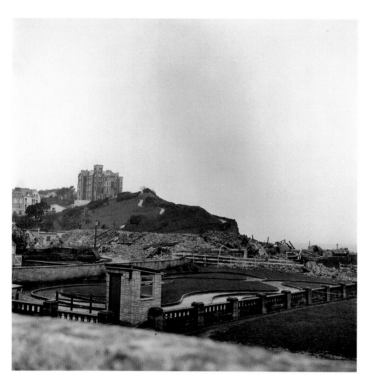

Tourism

For well over 150 years Ilfracombe has relied on tourism as its main source of income and here is the centre of that trade. Our first shot dates from January 1977 and is dominated by rubble from the just-demolished Ilfracombe Hotel. The contemporary photograph is a much more pleasant view with the Landmark Theatre and the Jubilee Gardens now in place.

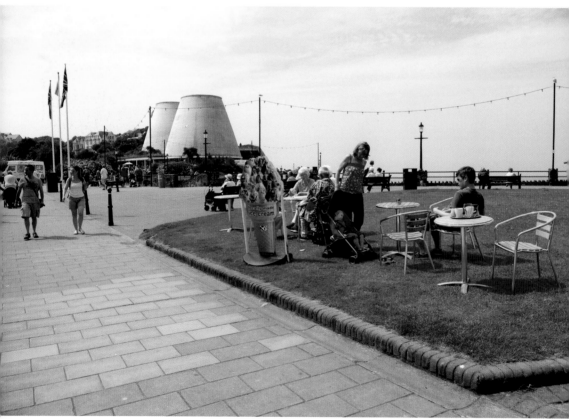

Alpha Boarding Establishment

This extraordinary building stands at the junction of Church Street and Wilder Road, being originally built as the Alpha Boarding Establishment. The unusual circular tower entrance makes the best and most eye-catching use of a rather constricted site. Refurbished a few years ago, the building now provides an exotic-looking entrance to the town, even if the modern road signs rather spoil the overall effect.

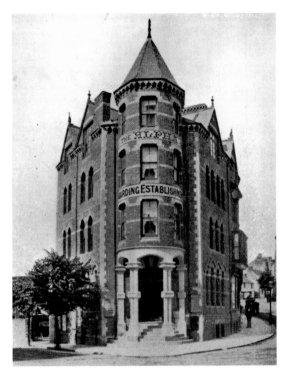

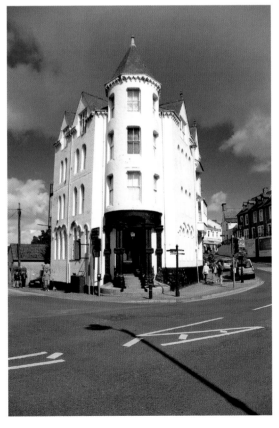

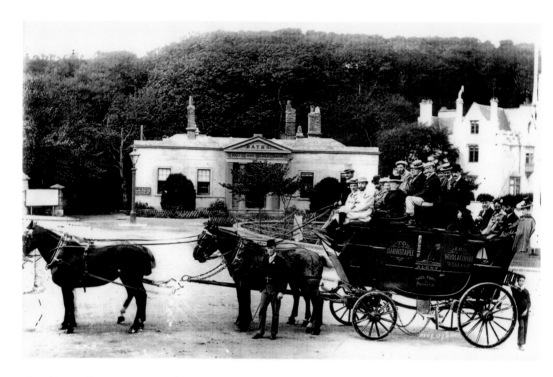

The Ilfracombe Sea Bathing Company

This wonderfully proportioned building was erected by the Ilfracombe Sea Bathing Company in 1836 to provide both hot and cold baths and to exploit the tunnels to the Tunnels Beach. The laden stagecoach was a must for trippers as shown in this 1896 photograph. Our modern shot shows the builders who are just completing a comprehensive refurbishment of the venerable building, bringing it back to its Victorian glory and making it a credit to the town.

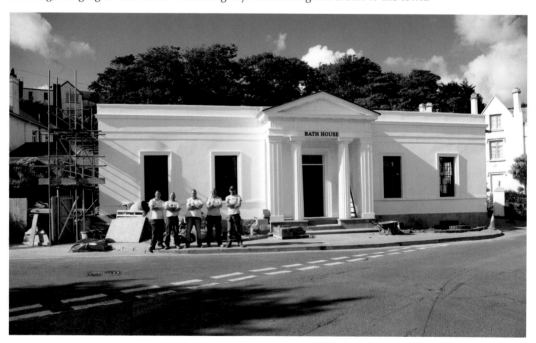

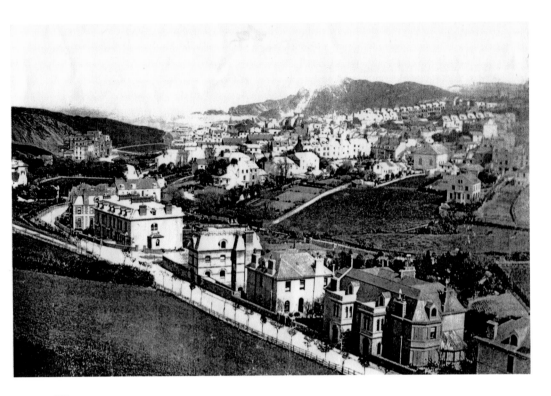

Infilling

As with all towns Ilfracombe has seen 'infilling' on its previously open areas – a trend well demonstrated in this pair of views looking from the west. The first dates from around 1900 whilst the 2012 one shows how much land has been lost.

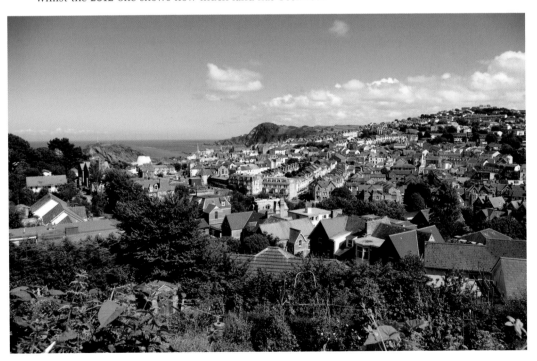

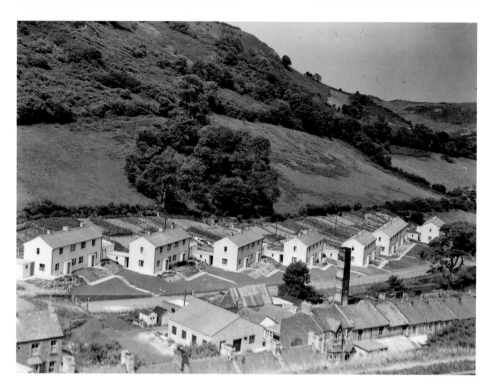

Slade

Slade is a pleasant, leafy suburb to the south of Ilfracombe's town centre with a mix of housing types. Our first photograph dates from 1951 when some new houses were being built, whilst our second, present-day shot shows how development has continued.

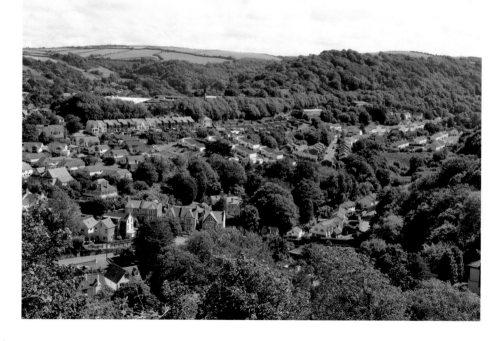

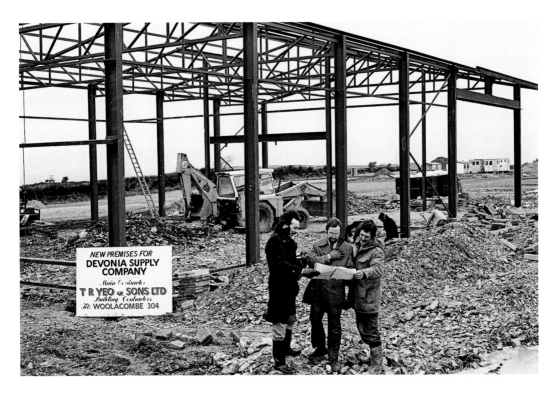

Mullacott Industrial Estate

The first shot here dates from February 1979 when the Mullacott Industrial Estate was first being laid out, with one of the pioneer factories under erection. The 2012 shot shows a flourishing area with a new wind turbine supplying electricity to local food distributor Philip Dennis Foodservice.

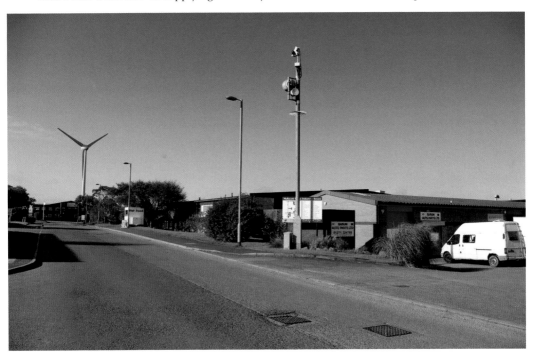

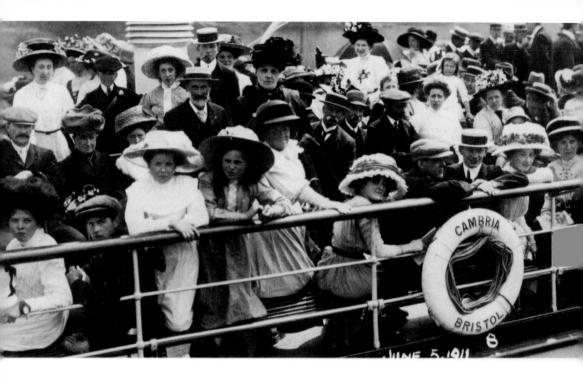

Boat Trippers

We couldn't have a book on Ilfracombe without either a photograph of a tourist boat or the trippers themselves. Our 'June 5 1911' photograph has an Edwardian crowd in large floral hats, flat caps and boaters on the *Cambria*, whilst the 2012 crowd is pictured on the *Oldenburg* with one person taking a photograph of our photographer!

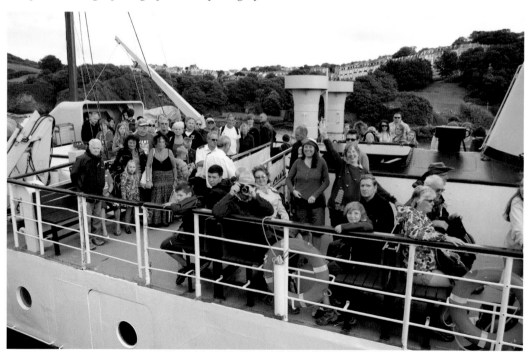

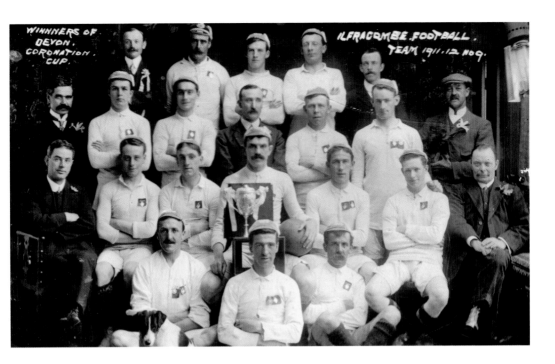

Ilfracombe Town Football Club

Ilfracombe Town Football Club plays in the Premier Division of the Toolstation Western League today, and is seen here along with all the backup staff and some of their supporters in a photograph specially posed for this book's photographer. An earlier team, from 1911–12, is shown holding the Devon Coronation Cup they won in that year.

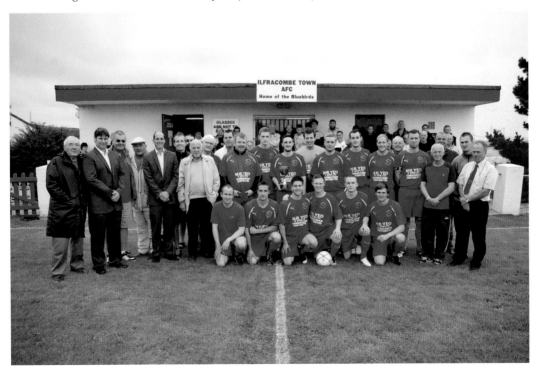

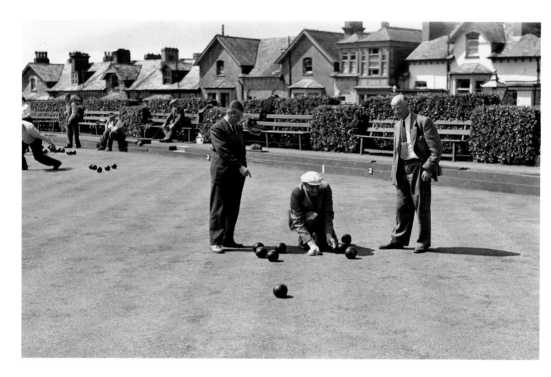

Ilfracombe Bowling Club

The Ilfracombe Bowling Club was formed in 1893 and its immaculate ground in Highfield Road has played host to many games, as seen in our June 1953 shot which shows a Mr Summerwill and Mr Dadds on the green. The 2012 photograph shows some of the members (of all ages) in their dazzling white clothing.

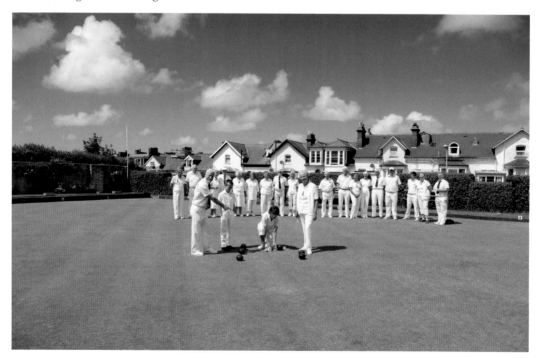

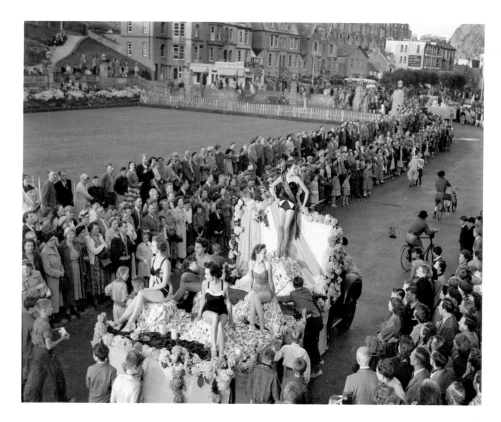

Beauty Queens

Ilfracombe beauty queens in the August 1953 carnival caught as they were going down St James Place towards the harbour – all in one-piece costumes notice, as bikinis had yet to arrive in Ilfracombe! Our modern shot shows the same view today, with the beautiful formal gardens now in place.

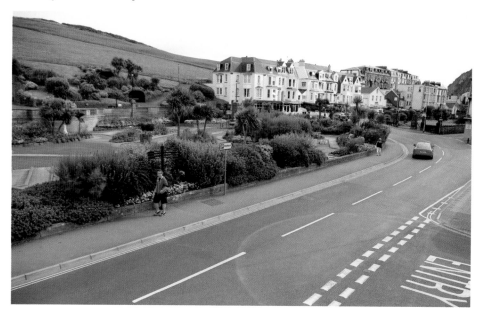

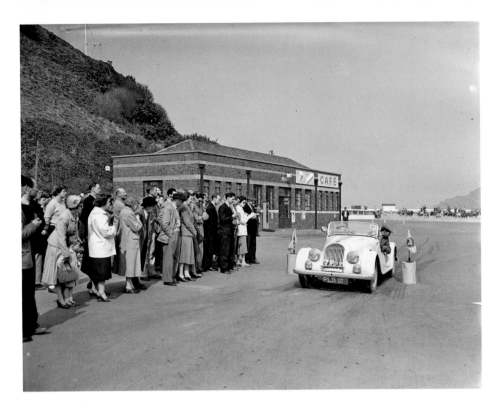

North Devon Motor Club

This April 1956 photograph captures two things: a North Devon Motor Club rally and the old café on the pier just below the chapel of St Nicholas. Today's cars look very different whilst the building now houses the harbourmaster and the Lundy Booking Office – with their friendly staff smiling for the camera.

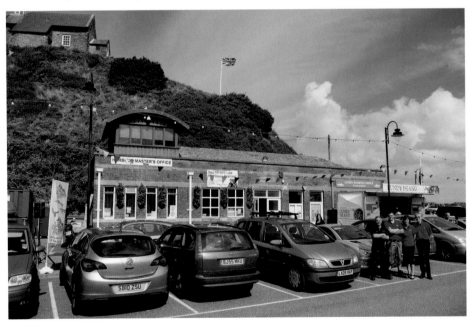

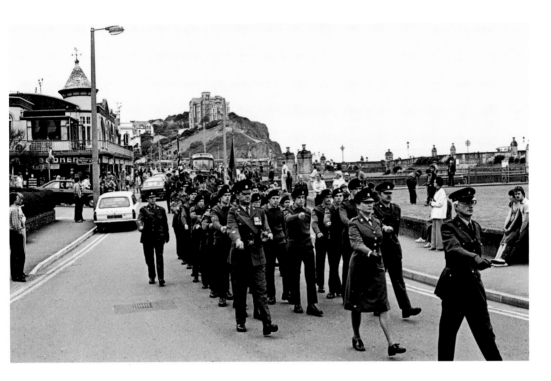

North Devon Army Cadets

In June 1981 all the various detachments of North Devon Army cadets combined to march through the town and are shown here passing the Promenade. The small, conical tower of the old Gaiety Theatre (built 1910) is caught in our second photograph, with the Landmark, built to designs by Tim Ronalds, filling the view at the end of the road.

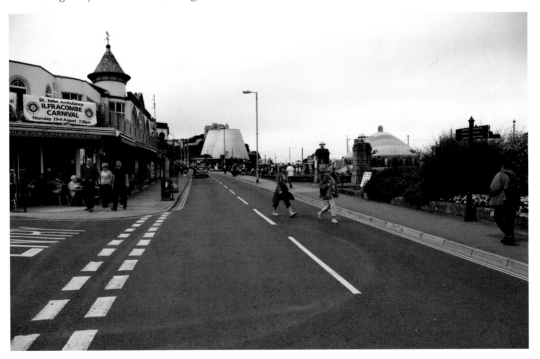

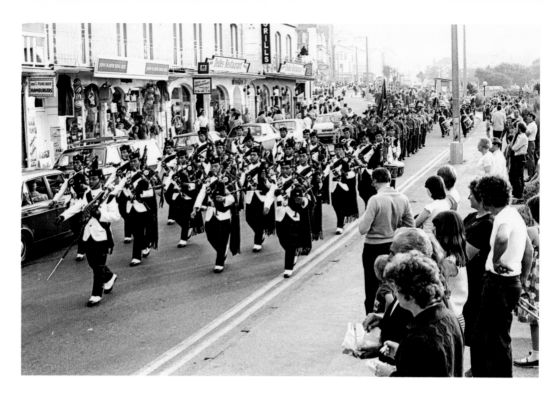

Gurkhas and Marines

Some rather unusual visitors to Ilfracombe in August 1981: a Gurkha bagpipe band parading along the Promenade with a Royal Marine band behind them on the occasion of the annual Ilfracombe Tattoo. Our second shot shows a rather less crowded area, and note the rather insubstantial replacement balconies along the architect W. H. Gould's 1880 development.

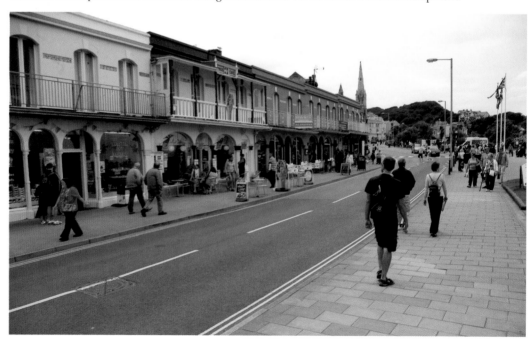

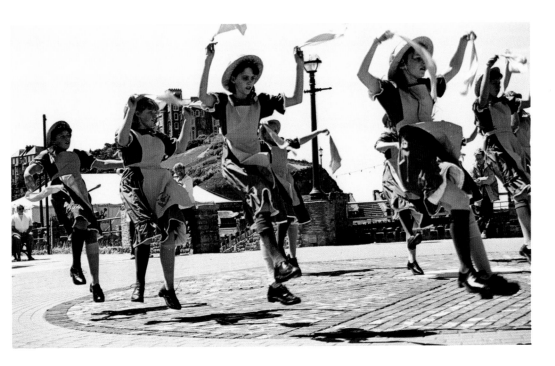

Capstone Parade II

The Capstone Parade is an open space just crying out to be used, and here we see two very different usages. Our July 1990 photograph shows all-female dancing group the Cloggies dancing on the seafront during the first-ever National Youth Arts Festival that was held in the town, whilst in 2012 we see a miniature 'pop-up' go-kart track.

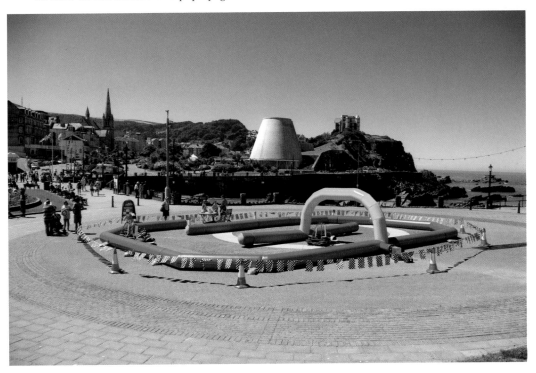

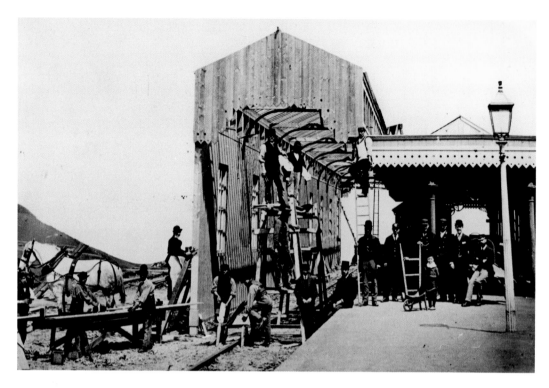

Ilfracombe Station

As already noted, the railway arrived in Ilfracombe in 1874, and here we see the erection of a section of the station designed to shield passengers waiting on the station from strong winds in this elevated position. Demolished nearly a century later, a new factory now occupies the site, and our photograph shows a William Hockin lorry, the favoured mode of transport today.

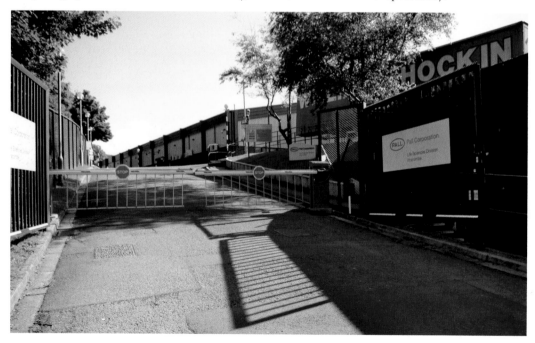

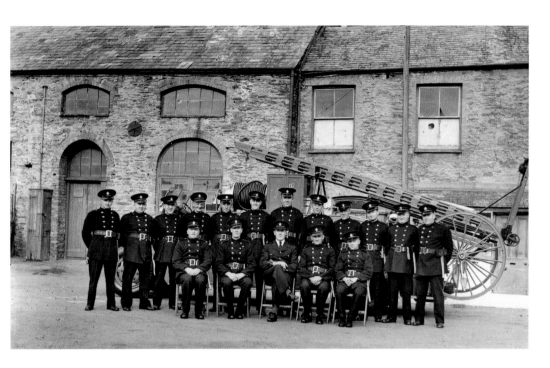

Ilfracombe Fire Brigade I

The old council yard in Wilder Road was the setting for this late 1940s shot of Ilfracombe Fire Brigade standing proudly in front of their old fashioned rescue ladder, with every fireman having a regulation hatchet hanging from his belt. Today the buildings have disappeared, to be replaced with a bland but very necessary car park.

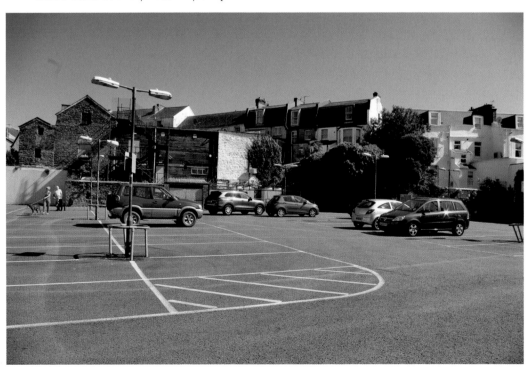

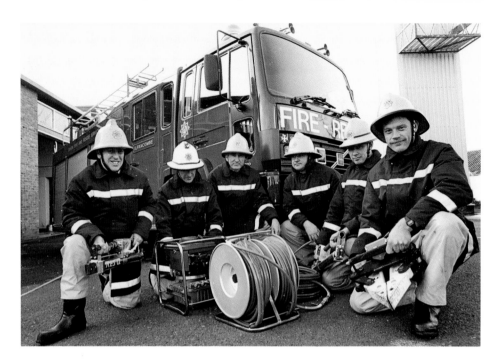

Ilfracombe Fire Brigade II

The history of Ilfracombe Fire Brigade begins in July 1876 when the council spent £156 on a new Merryweather engine with helmets and uniforms being supplied to the volunteer members in March 1877 under their leader Captain Simmonds. Our photographs show the brigade in February 1990, from left to right: Colin Piper, Dick Foss, Raymond Rudd, John Holton, Dick Osborne and Rhys Evans; with, for comparison, members of the 2012 team shown with some of their modern equipment in front of today's fire station. From left to right they are: Mark Creek, John Nolan, Robert Hancock, Jon Bourne, Peter Hancock and Daniel Lester.

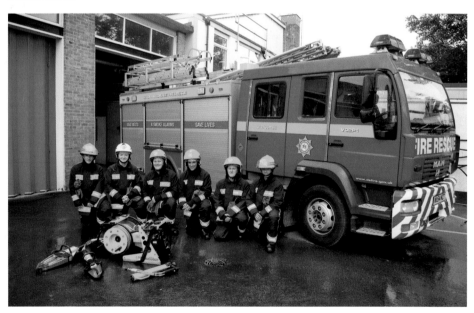

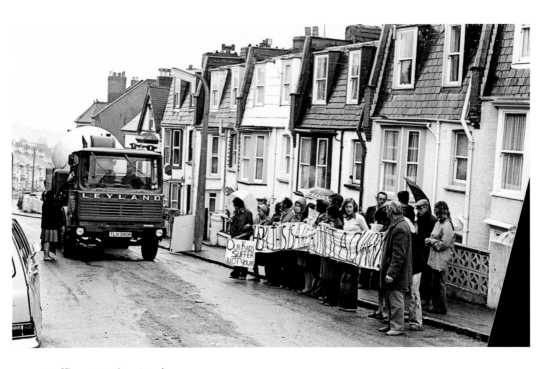

Traffic on Station Road

Most British towns weren't built to cope with the ever-increasing number of vehicles on the road, and occasionally public feeling expresses itself in protest. In September 1978 residents of Station Road staged this protest against the use of their road by heavy lorries being employed to help build the new Pall Europe factory. Today the scene is more peaceful, although double glazing seems *de rigeur*. Try and spot the four people waving at the photographer.

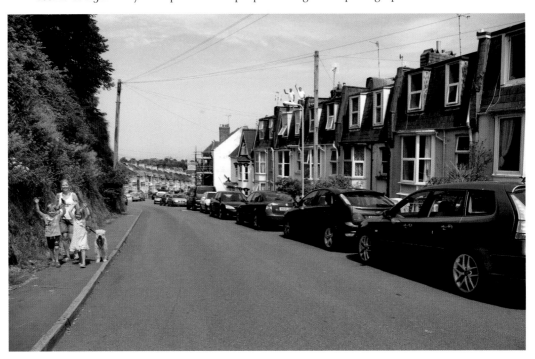

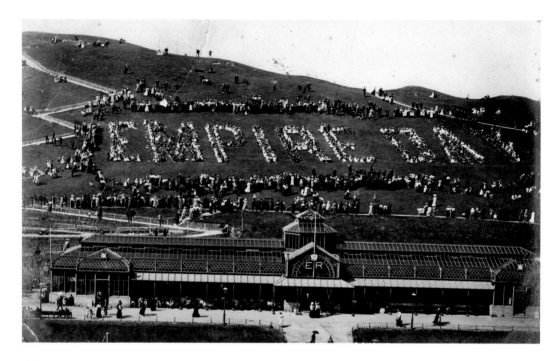

The Capstone II

The Capstone has always acted as a natural display area, as clearly seen on this 1909 postcard showing local school children spelling out 'Empire Day'. The monogram 'ER' for King Edward VII is on the Victoria Pavilion. Our new photograph demonstrates how lucky Ilfracombe is to have this green area right in its centre.

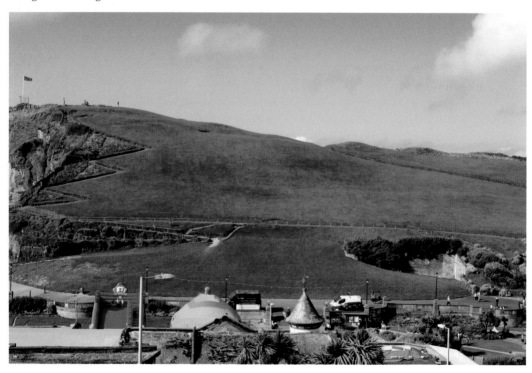

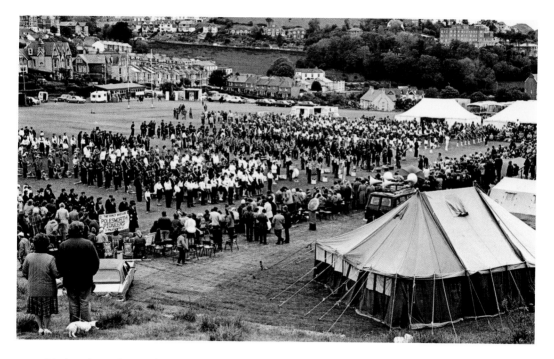

National Youth Marching Band Championships

Ilfracombe and large-scale events are synonymous. Our first shot dates from June 1984 when the town's Blazing Sounds marching band hosted the National Youth Marching Band Championship at Brimlands. Some 1,000 young people in twenty bands took part. The contest was won by the Bristol Unicorns, with Blazing Sounds winning prizes for their wind section, colour guard and general showmanship. Our 2012 photograph shows some of the year's carnival entrants at the Hillsborough Road car park getting ready to take part in the annual spectacle.

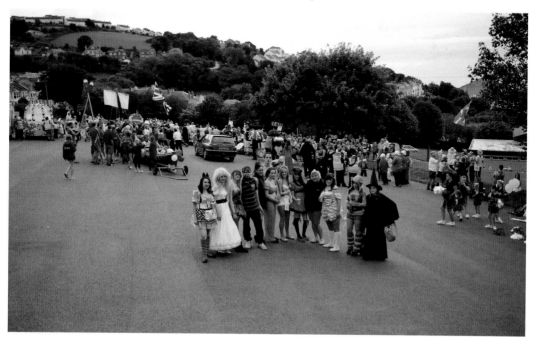

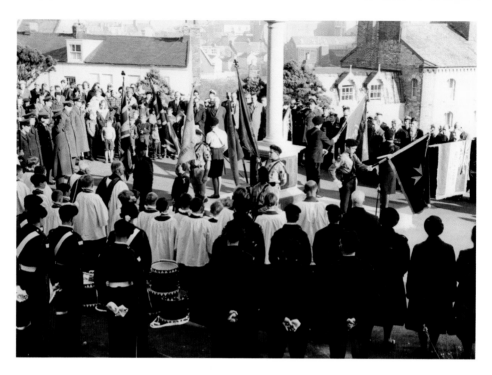

Ilfracombe War Memorial

The Ilfracombe war memorial is a handsome pillar topped with a figure of 'Winged Victory' standing at the entrance to the parish church of Holy Trinity. Our first shot shows a 1960s (we think) Remembrance Day service with representatives of many organisations present whilst our 2012 shot shows the powerful simplicity of the monument that records the names of 157 First World War and sixty-two Second World War dead from Ilfracombe, as well as four others who died whilst serving their country.

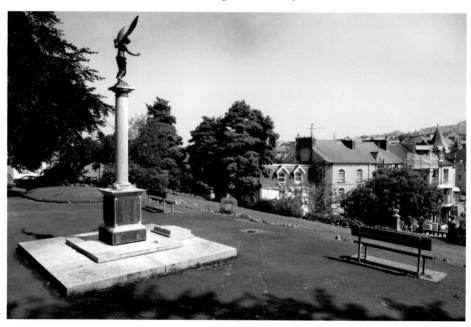

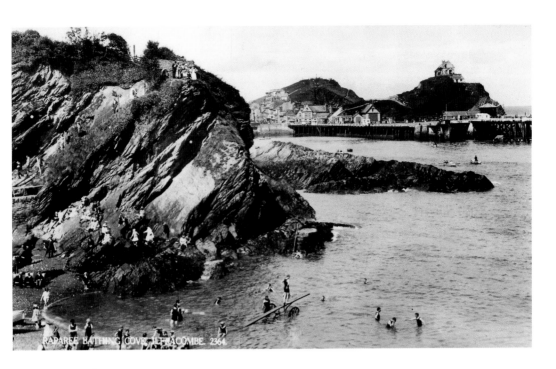

Raparee Cove

This small sheltered beach is Raparee Cove, which has provided a relatively safe bathing area for locals and tourists alike for many years. The shore was crowded in the Edwardian postcard; not so in 2012, with its rather dismal summer!

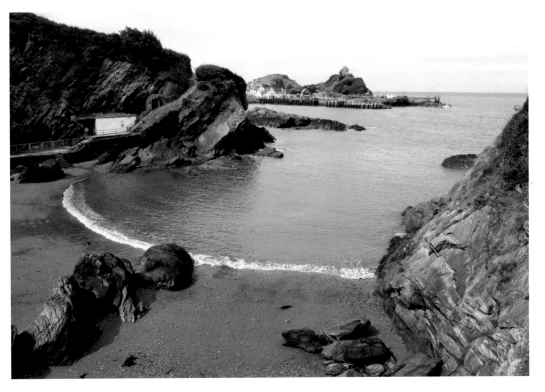

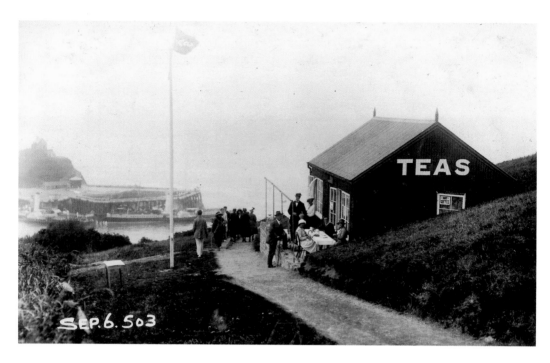

Mr Whidden's Refreshment Hut

Tourist areas need tea rooms and here on a 1920s postcard we see Mr Whidden's refreshment hut on Hillsborough. The hut was built by him, whilst he paid £20 per annum for the site. It was apparently blown over the cliff in 1938, leaving just some concrete footings and the lovely vista seen today.

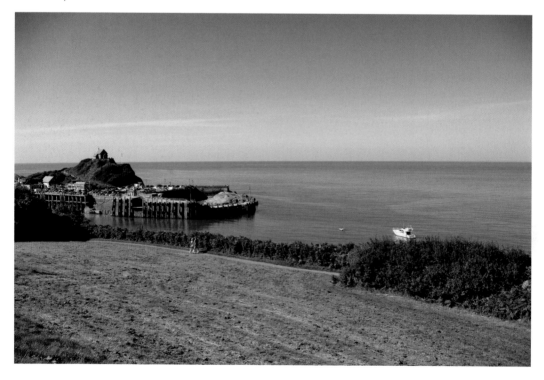

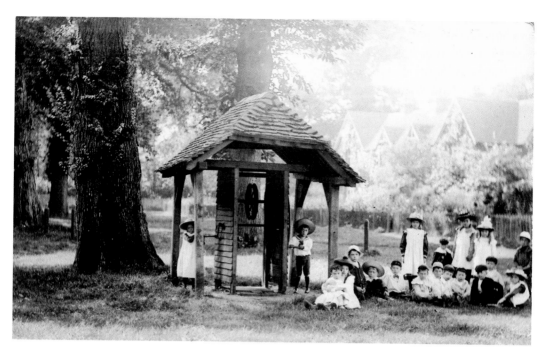

Bicclescombe Park

This view doesn't exist today as it shows the old wishing well in Bicclescombe Park around 1904 with the children in spotless clothes, including the then very fashionable sailor suit of the boy. The well is long gone but the park still plays host to families, as in our shot of 'Community Day' at The Old Mill Tea Rooms in the park.

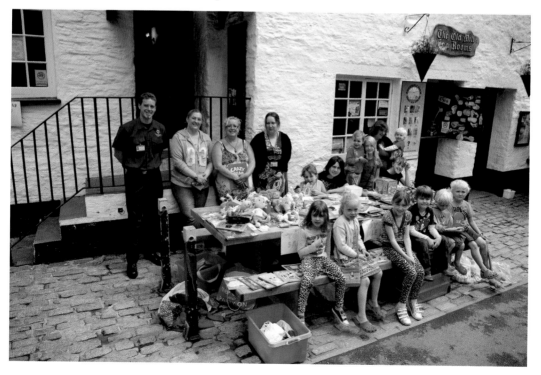

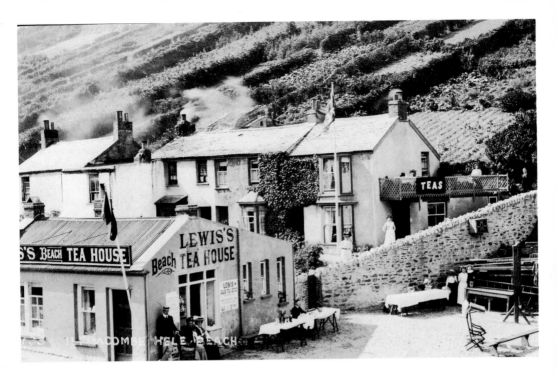

Hele Bay

Hele Bay to the east of Ilfracombe has long been a favourite spot to visit. Needless to say locals, including a Mr Lewis, realised they could have a profitable business supplying refreshments, hence these 'Tea Houses'. The original building can just be made out in our 2012 photograph.

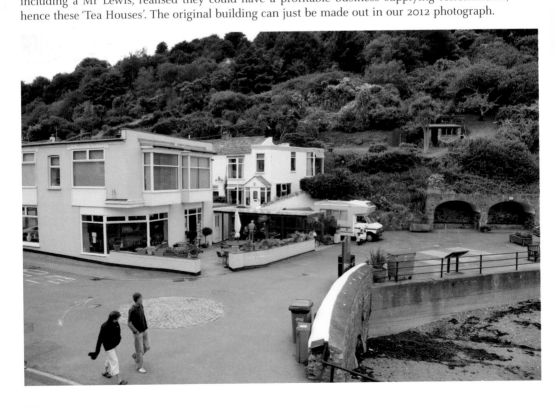

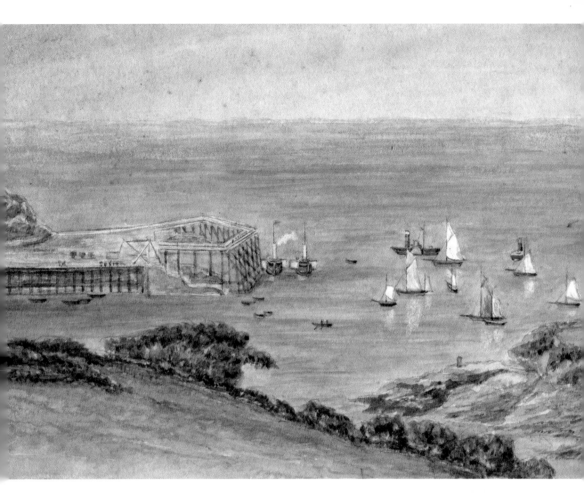

Ilfracombe 1885
Ilfracombe pier with two paddle steamers alongside in a 'naïve' painting dated 14–16 July 1885 by 'K. H. T.' from a viewpoint in 8 Larkstone Road.

Acknowledgements

We would like to thank Tom Bartlett for the loan of some of the images from his unrivalled collections. Many of the historic images were taken for the *North Devon Journal* and are now held in the North Devon Athenaeum in Barnstaple who are gradually putting them on-line – check their site for the latest additions – www.northdevonathenaeum.org.uk/. We must also extend our heartfelt thanks to the staff of the Ilfracombe Museum and many local people who willingly answered all our questions – and a special thank you to those people who posed for us in the modern photographs.